Lancaster,
Morecambe & Heysham

NIGEL DALZIEL
& SUSAN ASHWORTH

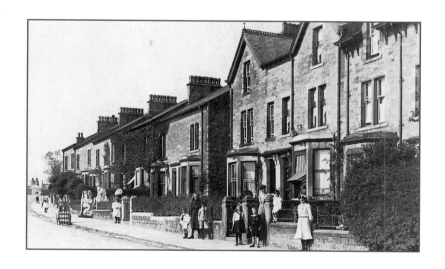

SUTTON PUBLISHING

Sutton Publishing Limited
Phoenix Mill · Thrupp · Stroud
Gloucestershire · GL5 2BU

First published 2001

Reprinted in 2001

Copyright © Nigel Dalziel & Susan
Ashworth 2001

Title page: Ashton Road looking towards
Lancaster. This postcard was franked in
1916, but it is likely that the photograph,
probably by Davis & Son, was a good deal
earlier. It records a new terrace of houses
begun in 1891. Notice the elaborate
railings still in place, many of which were
removed in the Second World War for
recycling.

British Library Cataloguing in Publication Data
A catalogue record for this book is available from the
British Library.

ISBN 0-7509-2382 2

Typeset in 10.5/13.5 Photina.
Typesetting and origination by
Sutton Publishing Limited.
Printed and bound in England by
J.H. Haynes & Co. Ltd, Sparkford.

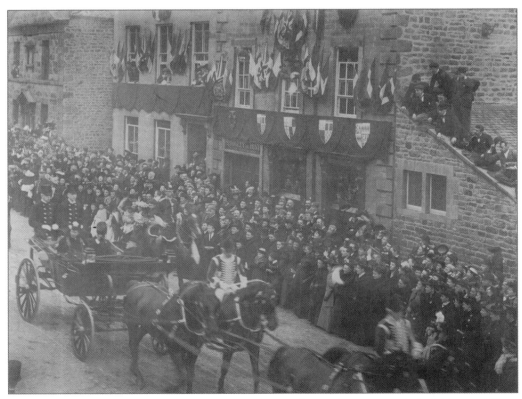

The Duke and Duchess of York en route to open the new hospital on 24 March 1896 (see p. 25).

CONTENTS

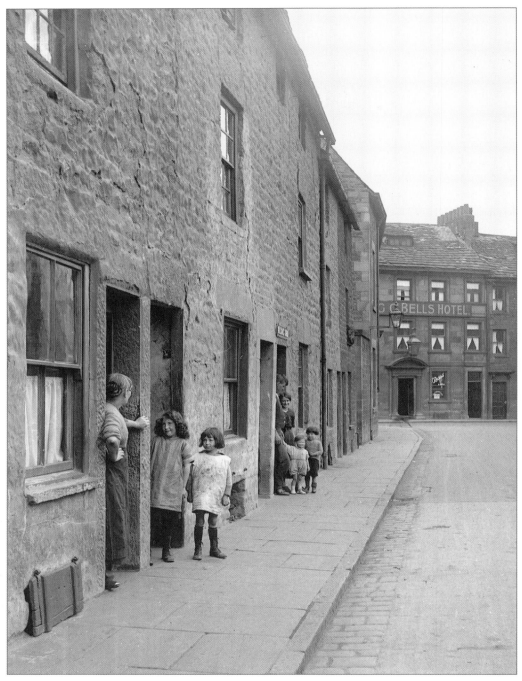

Spring Garden Street in Lancaster looking towards King Street, May 1927. Part way along this terrace of houses the entrance to Wilson's Yard is just visible. Lancaster had many small yards, courts and alleyways tucked behind the street frontages. Like many in the city this was targeted for clearance in the mid-1930s. We believe the yard and parts of Spring Garden Street were demolished in the winter of 1937/8.

INTRODUCTION

The area of the country featured in this volume of photographs is rich in history and varied in its geography. It corresponds roughly to the current Lancaster District administered by the City Council. This is also, pretty much, the ancient Hundred of Lancaster South of the Sands. At its heart lies the old county town, with its busy markets, services and industry, which became a thriving port in Georgian times. Not surprisingly Lancaster is afforded a major part of this book and the photographs concentrate on the period from the end of the nineteenth century to 1937 when, on the eve of the coronation of George VI, city status was conferred on the town. These photographs, however, are amply complemented with others from the coastal communities across the district where fishing, boat-building, port activities, leisure and tourism have proved so important to the history and wealth of the area. Sunderland Point, Heysham, Morecambe and Glasson Dock all hold significant positions in this book as do the waterways of the district. Equally important for the growth and development of the area is the surrounding countryside with its long tradition of farming and its own small-scale industries.

These places and activities have been recorded by talented amateur photographers and a number of professionals who set themselves up in business across the district, starting in the 1860s. In 1896 there were six studios in Lancaster and eight in Morecambe. Some businesses seem to have thrived for many years. In the City Museum's trade directories, for example, we found John Davis listed for the first time in Market Street Chambers in 1881. His sons became involved and the business could still be found there in 1934. However, by 1956/7 the studio had gone.

Amateur photography was very popular in the region. We have relied heavily on these images every day in our work at the museum. The Lancaster Photographic Society was established on 16 April 1889. It appears to have been a raging success and still provides a focal point for these talented people. In the Society's first twenty years it boasted some 387 members. They were not all from Lancaster: about fifteen were from Morecambe and twenty-four came from elsewhere around the district. However, they were all men!

We have used the collections of Lancaster City Museums, once more, as the main source of images. These collections reflect something of the character of local photographic traditions since the development of the medium. The two main areas that

An unknown little girl, perhaps a member of the Cutts family, photographed by Davis & Sons of Lancaster, *c.* 1900.

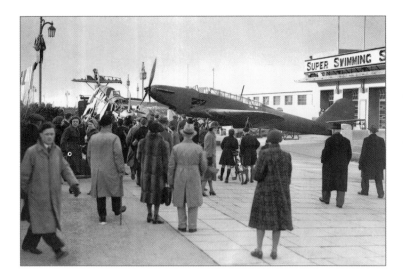

A display of aircraft close to Morecambe's Super Swimming Stadium exhibited as part of National Savings War Weapons Week, November 1940. Photographed by staff on the local paper, this is one of a large collection that give a flavour of the area during the Second World War.

predominate in our collections are portraits (mainly studio portraits, both family and formal) and views. A large percentage of the collections is in the form of photographic or printed view postcards. After the Post Office relinquished its monopoly on producing postcards on 1 November 1899 the stage was open for local production of photographic cards. From 1902 the format of the postcard with a full image on one side and both address and message on the reverse became the norm. A number of local photographers produced their own ranges of cards – in Lancaster those of Davis & Sons, George Howarth, William Johnston and Wynspeare Herbert are well known. Postcard collecting began in earnest and remained popular both for sending local messages and for holiday greetings. In 1931, for example, 1,220,638 postcards were sent from Morecambe!

Postcard-format photographs were also a very popular way of recording significant events – such as pageants, processions, weddings and royal visits, and dramatic incidents like tram accidents, fires and floods. Our collections hold all of these. Sometimes you can find the same images in postcard and card-mounted form for framing.

The museum collections are not without their weak points. Despite the acquisition of the extensive collection of postcards amassed by the late Robert Alston we still have uneven coverage of the villages surrounding Lancaster. However, on the plus side, we do have several caches of images that provide fascinating viewing and add substantially to our knowledge of the topography and social history of our district. I am thinking particularly of the many images by John Walker focusing on shipping on the River Lune, the fishing community at Sunderland Point and portraits of his own family. There is also the large collection of buildings, yards, alleyways and streets – many with their residents – recorded by Sam Thompson in the late 1920s when demolition threatened. More recently, we acquired a number of dramatic images of Lancaster during the Second World War taken by unknown photographers at the *Lancaster Guardian*. Last, but by no means least, the many views of everyday life in the city captured by Albert Gilham in the 1960s provide a wealth of evidence of the continuity and change in our area. Without any of these images the collections at the City Museums would be much the poorer. We hope you enjoy these photographs as much as we have enjoyed choosing what to include and what to leave out.

1

Around the River Lune

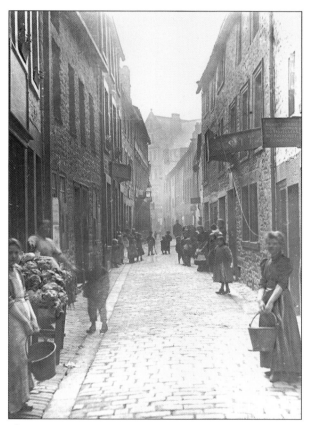

China Lane, Lancaster, looking towards the King's Arms
Hotel, *c.* 1893.

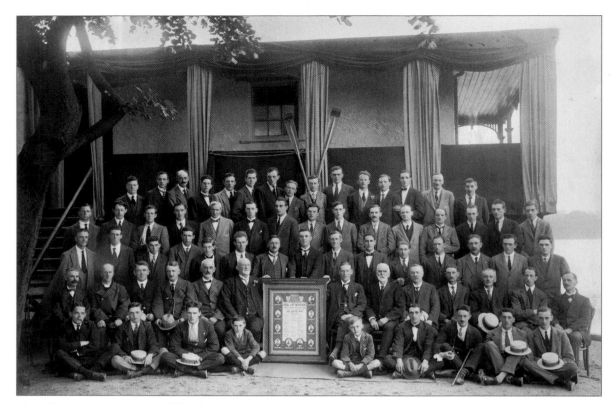

The John O'Gaunt Rowing Club, Skerton boathouse, Lancaster, displaying the Roll of Honour which listed all eighty-three members who served in the First World War of whom ten were killed. This photograph was taken on 5 July 1921 when the Roll of Honour was unveiled by the club captain and town mayor, Alderman G. Jackson, who said: 'Everyone whose name was on the list were good lads who took a deep interest in the club which was worth a lot. It created a manly spirit. The very fact that eighty-three members joined up showed the spirit of the club and the committee had done the right thing in preparing that beautiful and moving memorial to those who died that we might live.' The Lancaster Rowing Club was founded in 1842. It was the first in Lancaster and, as a result of a split in 1867, parent of the John O'Gaunt Club which is still active today. It makes the club the fourth oldest surviving rowing club in Britain.

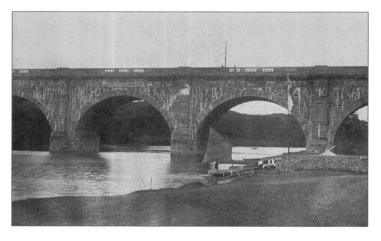

The Lune Aqueduct, which carries the Lancaster Canal across the river to the north-east of the town, was built in 1797 and designed by the great civil engineer, John Rennie. It is said to be the largest masonry bridge in the country and cost a staggering £48,320 18s 10d. It spans a particularly attractive stretch of waterway between Skerton and Halton, and in this photograph an enterprising boat owner is possibly hiring out the vessels drawn up on the riverbank.

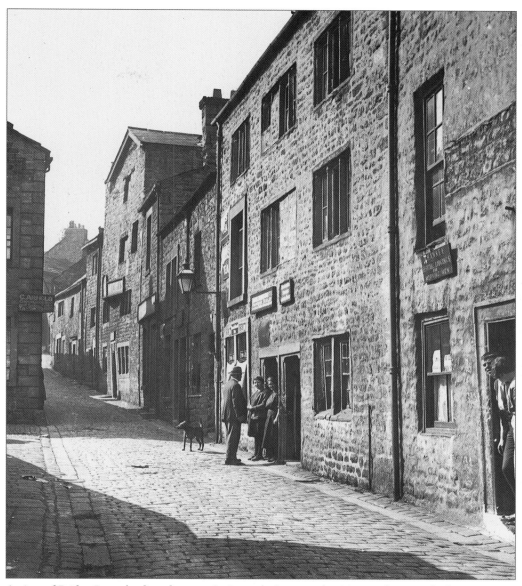

A view of Bridge Lane, leading down to St George's Quay, in the 1920s. This was the historic route through Lancaster to the Old Bridge on the main west coast highway between Scotland and the south. In places the roadway was only 8 ft wide which hindered traffic, although when Skerton Bridge was built in 1788 these problems were overcome. Bridge Lane became less busy and the buildings themselves became increasingly dilapidated. In the nineteenth century it was very down-at-heel and a number of lodging houses were established to cater for travellers whom the Lancaster chief of police, in 1886–7, suggested were largely criminals and wrongdoers of various sorts. The police kept a constant watch on these boarding houses and filed annual reports to the town hall. On the right of the photograph was B. Hankey's 'Respectable Lodgings for Working Men' and on the gable wall to the left is advertised C. Arnold's 'Common Lodgings', boasting 'Good Accommodation'. Regrettably, the area suffered from the town's fits of 'slum clearance' and most of Bridge Lane was demolished between 1937 and 1938.

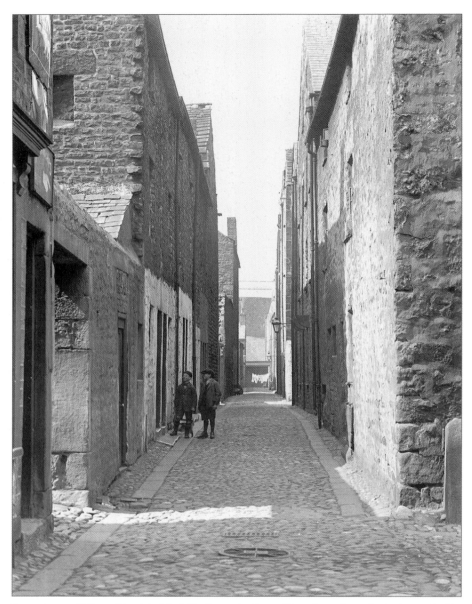

Two views of River Street behind St George's Quay. The view above looks towards the Custom House yard, behind the washing, taken on 11 May 1927 by Sam Thompson; the photograph opposite was taken facing in the other direction towards Vicarage Terrace. The quayside was built by the Lancaster Port Commission from the 1750s to cater for Lancaster's growing trade with the West Indies, North America and the Baltic. Land behind the river frontage was divided up into more than 100 plots and sold to merchants and tradesmen who set about building warehouses, workshops and homes. A number of these houses were occupied by coopers, sailcloth-makers, mariners and others associated with the port, but later in the nineteenth century several were rented to factory workers. From the 1920s many were demolished in slum clearance work, although the quality of the housing did not necessarily justify the term.

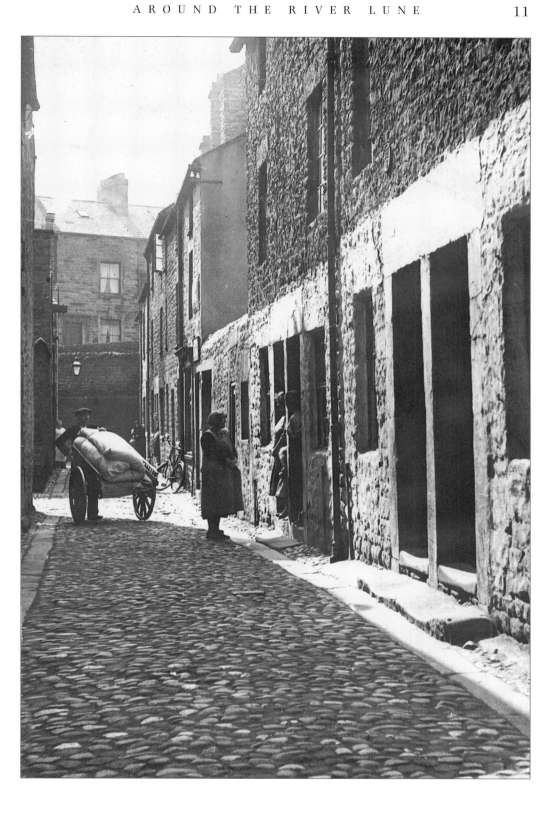

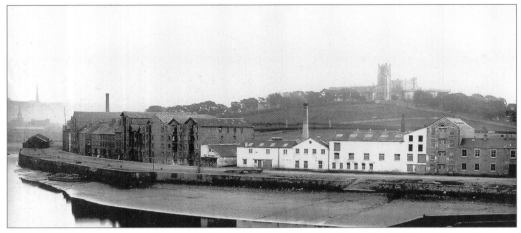

St George's Quay, Lancaster, from Carlisle Railway Bridge, probably in the 1890s. The warehousing and other buildings dating from the late eighteenth century have now mostly been converted into flats. Along the quayside are the original mooring stones and slipways at right angles to the quay, which was conveyed to Lancaster Corporation in November 1901 and laid out as a pleasant riverside promenade. The landing sheds (to the left) were demolished in 1902.

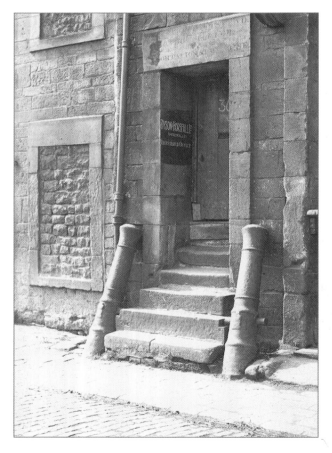

A large number of ships were owned and operated at Lancaster in the eighteenth century and mostly employed in trade to the West Indies, the Baltic and Africa where slaves were purchased for sale to plantations in the Caribbean and North America. Many of the ships were armed for self-defence or for attacking ships of enemy nations, but with the end of the war with France in 1815 the cannons became redundant and found other uses. Some protected the steps and corners of warehouses from road traffic, as in this photograph outside Dyson & Horsfall's office in the 1920s. Above the door are the faint remains of lettering advertising the firm of Arthur Armistead, spirit and porter merchants, recorded operating on the quayside as early as 1809. Sadly, the cannons were removed in the Second World War supposedly for recycling.

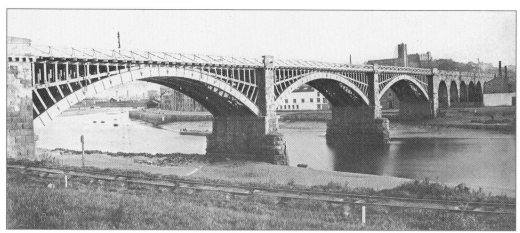

Carlisle Railway bridge crossing the River Lune, Lancaster, before it was rebuilt in 1866. The Lancaster & Carlisle Railway was opened at Lancaster on 21 September 1846 and today it continues to form part of the main west coast railway line connecting Glasgow and London. The bridge took the railway across the river on eight stone arches flanking the three large timber spans, each 120 ft wide. A total of 30,000 cu. ft of timber was used in its construction which took only a year to complete. It was rebuilt for the second time, in steel and concrete, in 1962–3. The original piers and stonework survive.

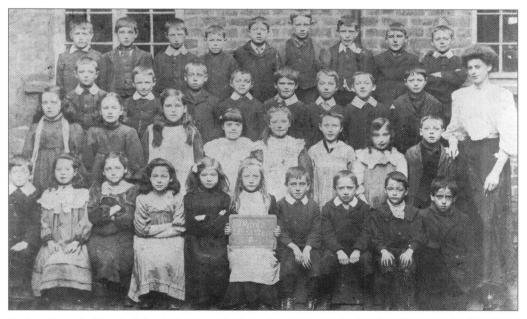

A class from St Mary's School, St George's Quay, Lancaster, early 1900s. The Church of England school was opened in 1880 in a converted warehouse formerly used by Messrs Storey Brothers, and mostly served the large number of poor families living on the quayside. Many of the parents worked in Williamson's linoleum factory further downstream. The school was well run and the teaching continued to maintain the standards praised in the inspectors' report for 1881: 'Reading and arithmetic are excellent, and the other subjects very creditable. The children are exceedingly attentive and well-behaved.' The school closed in 1944.

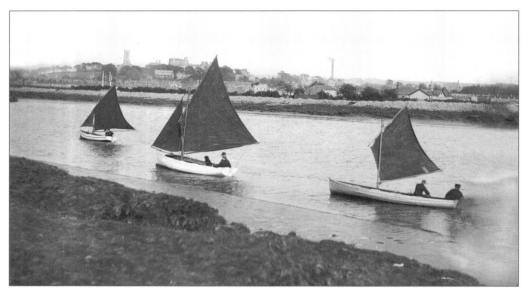

Local regattas, involving rowing and sailing, were established at Lancaster, nearby Snatchems, Sunderland Point and Poulton-le-Sands in the early nineteenth century. They were often rowdy affairs. In 1844, for example, a labourer, William Townson, was elected 'mayor' at 'Snatchems Sports' and 'he was so elated with his accession to civic honours that he got right royally drunk' (*Lancaster Guardian*). He was later arrested for fighting in Bridge Lane, Lancaster. This sailing competition between Snatchems and Carlisle Bridge in the 1890s was a quieter affair and reflected the growing use of the River Lune for leisure pursuits at that time. In front of Williamson's St George's Works (below) is the newly rebuilt and extended quayside officially named Ford Quay by the Port Commission in 1891.

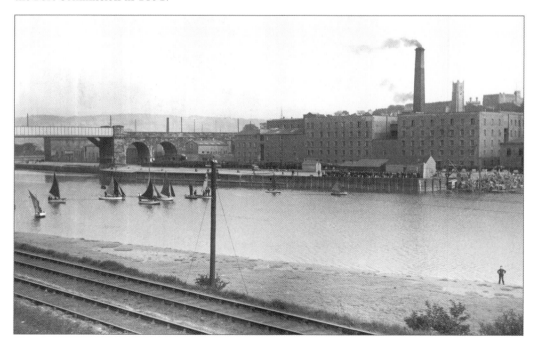

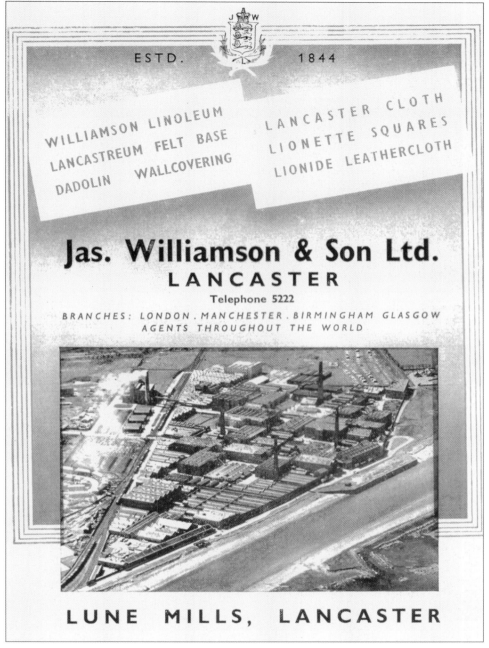

ESTD. 1844

WILLIAMSON LINOLEUM
LANCASTREUM FELT BASE
DADOLIN WALLCOVERING

LANCASTER CLOTH
LIONETTE SQUARES
LIONIDE LEATHERCLOTH

Jas. Williamson & Son Ltd.
LANCASTER
Telephone 5222

BRANCHES: LONDON . MANCHESTER . BIRMINGHAM GLASGOW
AGENTS THROUGHOUT THE WORLD

LUNE MILLS, LANCASTER

Company advertisement, 1960. James Williamson & Son Ltd, founded on St George's Quay in 1844, became one of the world's largest producers of oilcloth, table baize, linoleum, window blinds, leather-cloth and related products. In 1848 an employee, William Storey, left to establish a rival Lancaster firm, which led to long-standing bitterness between the two firms and families. In 1870 Williamson bought the redundant shipyard site downstream at New Quay and began to develop the huge 96 acre Lune Mills which, it was observed, 'are the most extensive in the universe that are owned and controlled by one individual'.

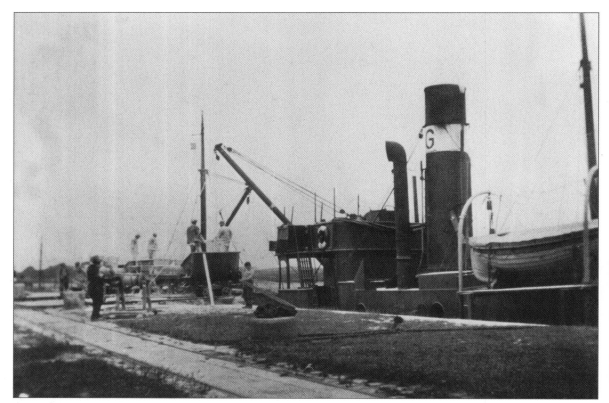

Williamson's factory complex beside the River Lune demanded constant supplies of china clay used in the manufacture of linoleum and oilcloth, as well as coal for fuel. The Lancaster shipbroker Robert Gardner established his own shipping line in 1920 and obtained a contract from Williamson's to supply these goods in bulk to New Quay. His ship *Mountcharles* (1910) can be seen here unloading 'whiting' from Cornwall, probably in the 1930s. Her last load was delivered on 4 January 1953 and on 28 March she was lost in bad weather off Hartland Point, Devon, en route to Lancaster.

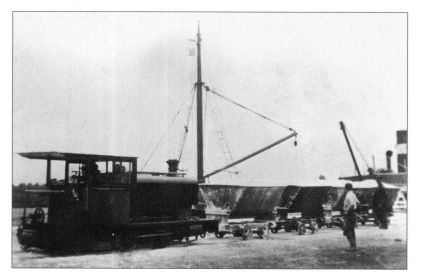

The china clay arriving from Cornwall was loaded into baskets manually, hoisted on to the quayside using the ships' derricks and emptied into the railway wagons. It was a nasty job. The dust got everywhere and covered the workmen from head to foot. The railway was only a light 3 ft gauge line built by Williamson's to service the factory complex and it extended on to New Quay in 1904. The engine is one of two Dick Kerr 0–4–0s operated by the firm.

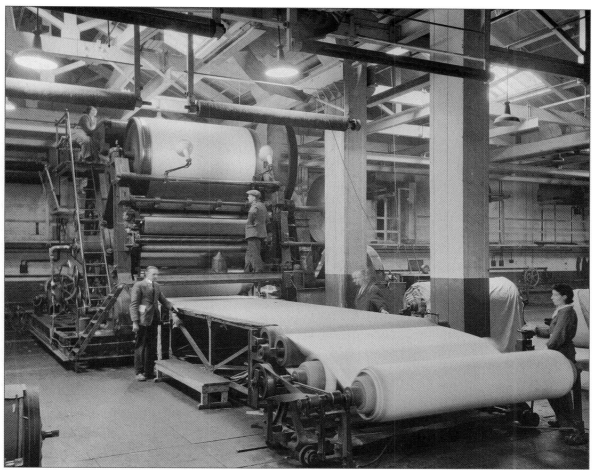

One of the pressing machines used in Williamson's Lune Mills complex in the inter war years. After the death of James Williamson – the founder of the firm – in 1879, his son (also James, later Lord Ashton) was even more successful in developing its fortunes, although the business remained his personal property and was not constituted as a limited company. Consequently, when he died in 1930 his estate was valued at £10,501,595, of which £5 million was paid in death duties – a great disadvantage to the company. Control passed to his son-in-law, the Hon. William Peel, who became chairman. He improved the management of the firm and modernised the manufacturing plant. As recently as 1961 the workforce numbered 3,000, making the firm Lancaster's largest employer. Because of a severe decline in the demand for floorcoverings by the early 1960s, however, Williamson's merged with the Nairn group of companies and the workforce was halved.

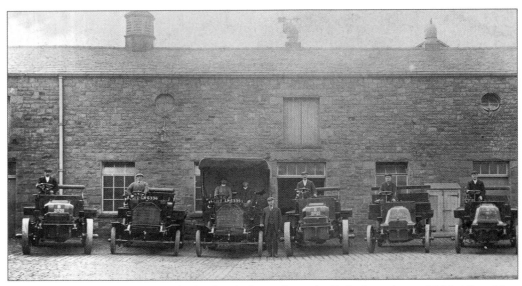

Williamson's transport staff with the firm's fleet of mostly flatbed trucks, *c.* 1910. The oldest vehicles have solid wheels, but the covered wagon and the one to the left, have advanced pneumatic tyres. However, it would have made little difference on Lancaster's streets with their traditional stone setts. The firm was very successful at this time, but from 1911 James Williamson II, Lord Ashton, began to turn his back on Lancaster, wounded by local criticism, and what he regarded as ingratitude for the employment he brought and for his many generous benefactions to the town. In his later years he lost interest in the firm and remained a recluse in Ryelands, his town house.

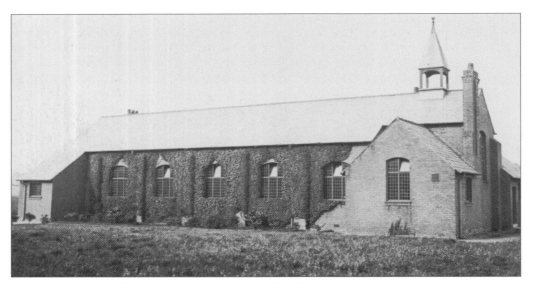

St George's Church, Willow Lane, Lancaster, *c.* 1907. The Marsh area had grown steadily during the late nineteenth century, and many new houses were built for workers at the nearby Williamson's factory. St George's Church followed and was built on Whittaker's Field in 1898 for £2,100. The *Lancaster Guardian* described it as 'a plain substantial structure, the walls being of brick, with buttresses between each window'. As a building it was not widely mourned when it succumbed to damp and dry rot and was demolished in 2000.

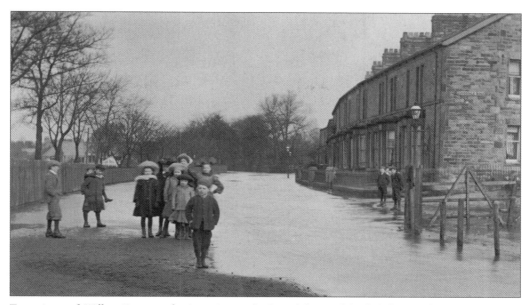

Two views of Willow Lane at the junction with Coverdale Road (right) during the great flood on 17 March 1907. The *Lancaster Guardian* reported that 'on Saturday night and in the early hours of Sunday the north-west coast was swept by a gale, the severity and destructive character of which has seldom, if ever, been equalled'. Very heavy rain and hurricane-strength winds coincided with the highest tide of the year, eventually estimated to be 29 ft. The whole coastal district was flooded to a depth of several feet and many Lancaster streets were affected. 'The warehouses and residences on the Quay were flooded to a considerable depth. Mr Pye and Mr Wells, corn millers, had stock damaged. The premises of Messrs Williamson and Son at St George's and Lune Works suffered to a very large extent . . . a number of the employees were roused and as far as possible the stock in the warehouses was removed to safer quarters', although between seventy and eighty wagon loads of stock were damaged. It took over two days for the flood to subside.

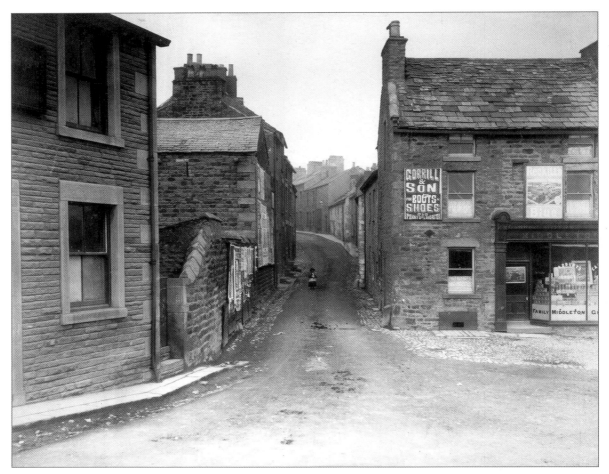

Entrance to Main Street, Skerton, viewed from Skerton Bridge on the north bank of the River Lune opposite Lancaster. The road was the main highway through the ancient village and led on towards Halton and the Lune Valley. It maintained its own separate existence and was part of the Lancaster Rural District Council until the end of the nineteenth century when it was absorbed, along with Bulk and Scotforth, into an expanding borough of Lancaster. On the right are some interesting advertisements which include one for 'Gorrill & Son for boots and shoes, 17 & 19 Penny Street', a firm which still survives selling household goods today. This area was subject to wholesale demolition in 1960 and many fine old buildings, some up to 250 years old, were destroyed in a programme of 'slum clearance'. Evidence at the planning enquiry, however, suggested that many condemned buildings could have been renovated both easily and cheaply.

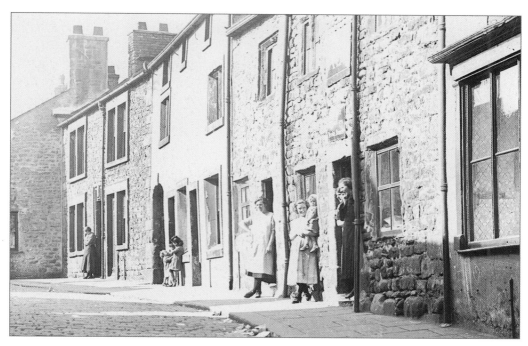

Main Street, Skerton, in the 1920s. Many homeowners in Main Street, Pinfold Lane and the Ramparts objected to the compulsory purchase orders made by Lancaster Corporation in the late 1950s prior to redevelopment of the area. The orders affected 137 houses, 8 other buildings and 9 plots of land. When eviction finally took place, some residents were re-housed in council estates such as Ryelands, built from 1931 on land belonging to the late Lord Ashton. The house below was typical of inter war public housing and no doubt a great improvement for some new residents.

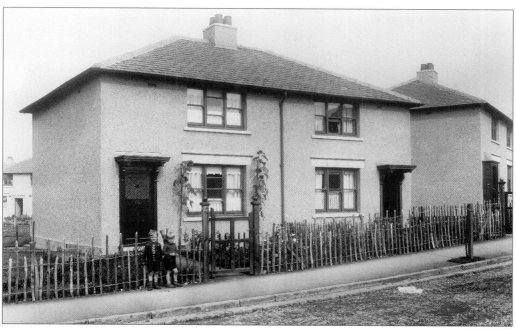

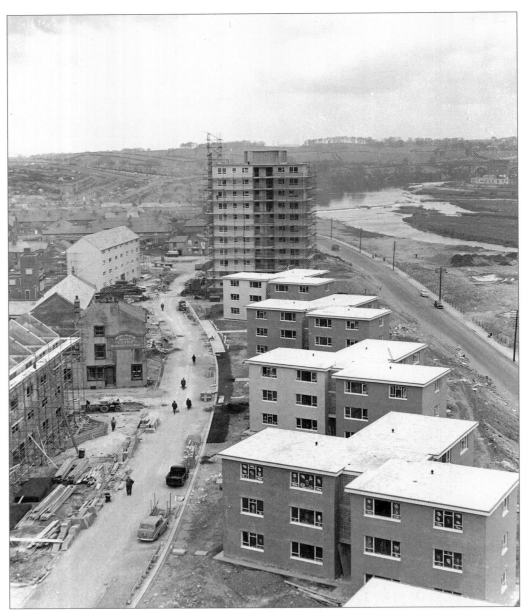

The changed face of Skerton in 1960, with the new three-storey blocks and eleven-storey towers between Main Way (left) and the Ramparts road (right). Thousands of tons of spoil from the redevelopment were dumped between the river and the new buildings, which led to the closure of the road at the end of September 1960. The area was then developed as an open space with riverside walks. The Town Clerk, J.D. Waddell, said: 'perhaps then in the future this might well be a popular weekend rendezvous where citizens might find relaxation and think that the City Fathers of this day and generation were not lacking in foresight in planning for the future'. The problem of that generation, however, was its futuristic vision. The opening of the eleven-storey blocks of flats was undertaken by Dame Evelyn Sharp DBE, Permanent Secretary at the Ministry of Housing & Local Government on 19 October 1960, followed by a slap-up lunch.

2

Around Lancaster

A novelty postcard, *c.* 1905.

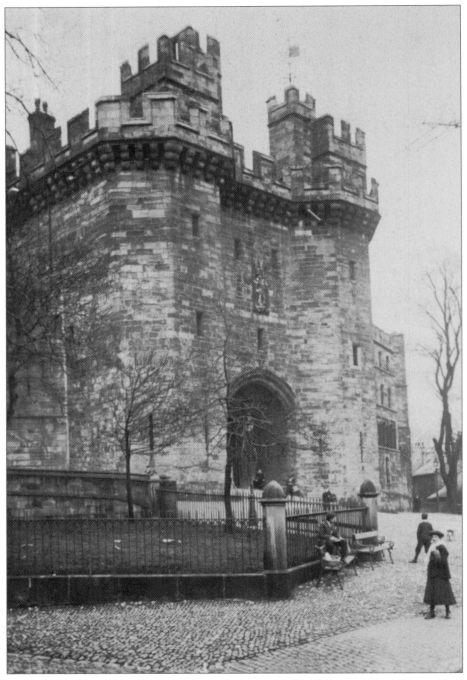

John O' Gaunt's Gateway, Lancaster Castle, photographed by George Howarth, c. 1905. The monumental gateway was built by Henry IV, John of Gaunt's son. His statue was not added until the 1820s. Not surprisingly, few changes have been made to this site. After the First World War a captured tank was housed behind the railings. However, during the Second World War both the tank and the railings were cleared away for salvage.

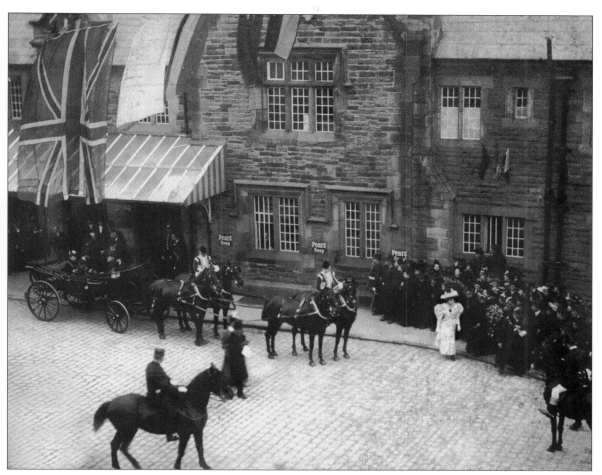

The arrival of the Duke and Duchess of York on 24 March 1896. The royal couple visited Lancaster to open the new hospital and to confer on it the title of Royal Lancaster Infirmary on Queen Victoria's wishes. The train arrived promptly at midday and the couple took a short tour en route to the old town hall. They are seen outside the renowned stained glass studios of Shrigley & Hunt where crowds lined the street and local schoolchildren gathered on the green to sing the National Anthem. After a brief visit to the town hall the duke and duchess travelled on to the Infirmary to perform the opening. They returned for luncheon at the town hall before departing mid-afternoon. In the meantime local cycle clubs held a fancy dress cycle parade around the streets with the Fire Brigade acting as 'copper catchers' – they raised £23 for the hospital.

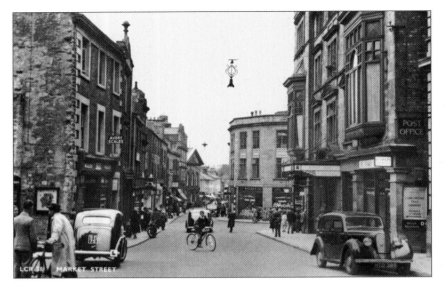

Market Street with the Kings Arms Hotel on the right, *c.* 1950. On the opposite side of King Street the new shop buildings of 1930 stand out in strong contrast to their Georgian and Victorian neighbours. The new post office building, just out of shot on the right, opened in 1922 on the site of a grand early nineteenth-century house belonging to Mr John Fenton-Cawthorne, Lancaster's MP. A small part of this house survives, rebuilt into the back of the Storey Institute opposite the castle.

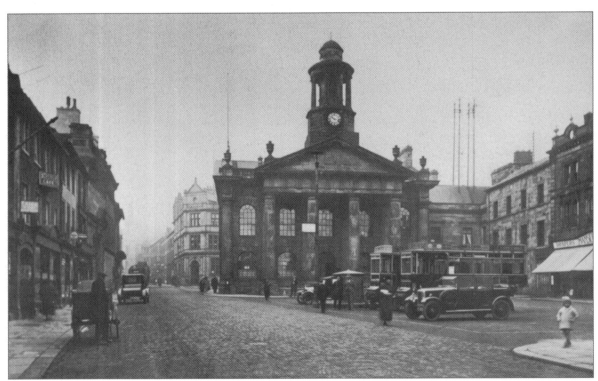

Market Square, *c.* 1920. This view is instantly recognisable with the old town hall, Lancaster's museum since 1923. However, the buildings to the right have all changed since the photograph was taken. In the corner of the square now is the library which was opened in 1932. Two years later Mansergh's department store (right) had a disastrous fire, and in the subsequent sale of damaged goods the police had to be called to restrain bargain hunters, and in 1958 the Co-op's new, remodelled furniture store opened out onto Market Square. Now this is the entrance to Woolworths.

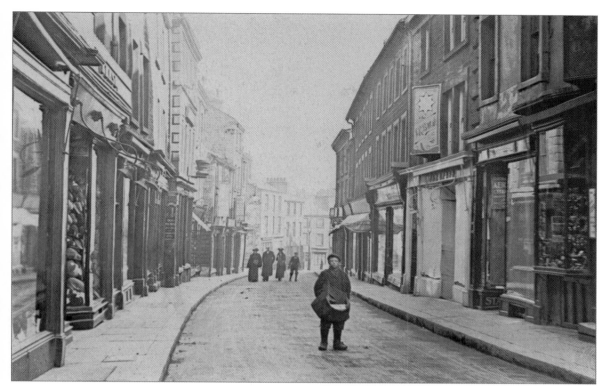

A view along Cheapside, towards North Road, from a postcard sent in 1905. This street was once known as Pudding Lane. It has always formed part of Lancaster's shopping centre. The pestle and mortar shop sign for a chemist is just visible on the left. It was first Ross's then Vince & Barker and finally Vince & Co. In this shop Edward Frankland, later Professor of Chemistry at the Royal Institution in London, served his six-year apprenticeship to the druggist Stephen Ross. There is still one example of this type of sign in King Street – a rare survivor of early signage on today's streets.

A party of regulars from the Brown Cow on Penny Street, c. 1925. In the 1825 trade directory Penny Street had nine hostelries, although one was untenanted. The Brown Cow is first listed in 1881 when Mr F. Cornforth advertised himself as a 'Brewer of Mild and Bitter Beer'. Woolworths, next door, moved from this end of Penny Street close to Horseshoe Corner, before leaving Lancaster altogether. The store returned several years ago to the former Co-op site in Market Square.

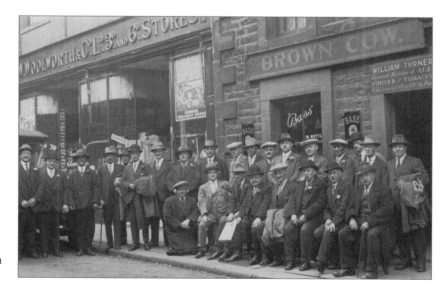

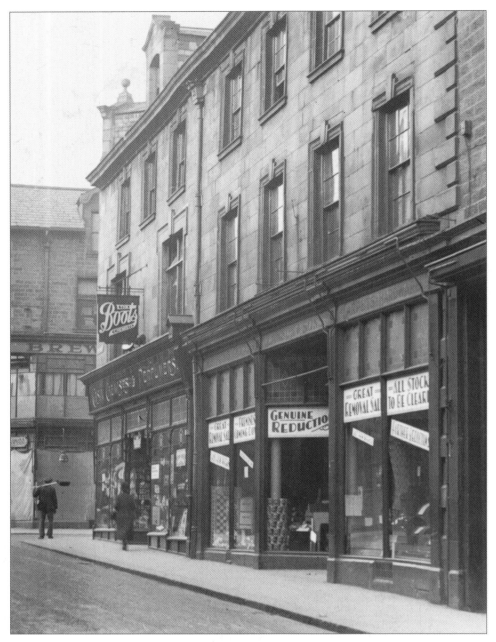

Boots and Lawson's shops on Penny Street, early 1930s. For those able to visit the site – on the corner of Common Garden Street – a ghostly image of Boots' logo can still be seen on the building along with the carved date 1912. This Nottingham-based business came to Lancaster in 1899 and was first found on the other side of the road, with Webber's photographers on the first floor. Lawson's well-known shop sign – the rocking horse – can still be seen on New Street. Their Penny Street premises were demolished and rebuilt in brick as Marks & Spencer's new, 'modern' art deco-style store. It opened in November 1933. Today the store incorporates both of the shops seen in the photograph.

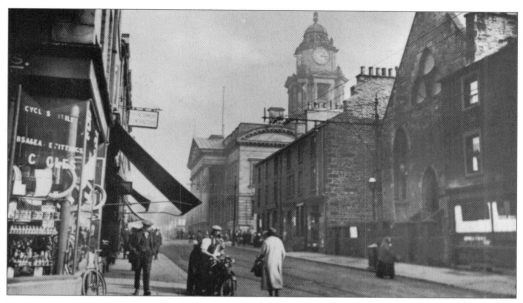

Brock Street from the junction with Penny Street, from a card postmarked 1932. Notice the tram lines and overhead cables still in place. Lancaster's tram service closed in 1930. The Evangel Temple on the right-hand side of the road was refurbished and opened as a restaurant in 1990. Beyond this, at the end of the road opposite the town hall, stood the house where the scientist Richard Owen was born. Owen became the first Curator of the Natural History Museum in London. Although he is not well known today, we all use the term dinosaur that he created.

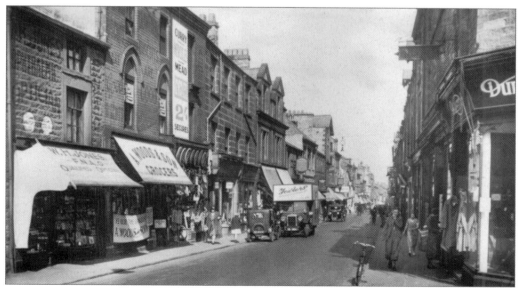

Penny Street from George Street, c. 1935. This is one of Lancaster's ancient roads, a principal route leading out of town to the south. It has long thrived on retail trade and continues to do so today. The store on the right is Durafit Tailors. It seems they had two premises in Lancaster in the 1930s – this one and another on Cheapside. If you stand on the same corner today and look above the shop fascias you will see that this stretch of Penny Street has changed very little.

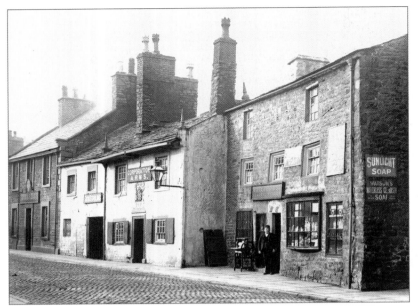

Penny Street photographed by Sam Thompson in April 1894. The two old inns stood side by side on the site of the Farmers Arms. It was at this point that tolls were paid on goods entering town from the south destined for market. These tolls were bought out by the local industrialist, James Williamson, in 1887 in an effort to reduce the costs of food at market. In 1901 this area was under redevelopment. The Corporation Arms, run by Ellen Hodgkinson, was functioning from temporary buildings before taking up the buildings now known as The Alex.

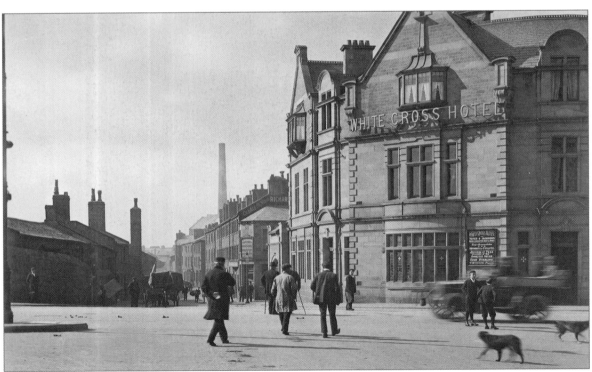

A view along Aldcliffe Road, c. 1910. At some point the new White Cross changed its name to the Farmers Arms. In the 1956 directory both names are listed together. The mill chimney in the background belongs to Queens Mill, a cotton spinning mill built in 1840. At this point it was used by Rembrandt Intaglio Printing, fine art printers that were part of the Storey family business. We believe that the houses, the Spinners Arms and Queens Mill were all swept away in the 1960s.

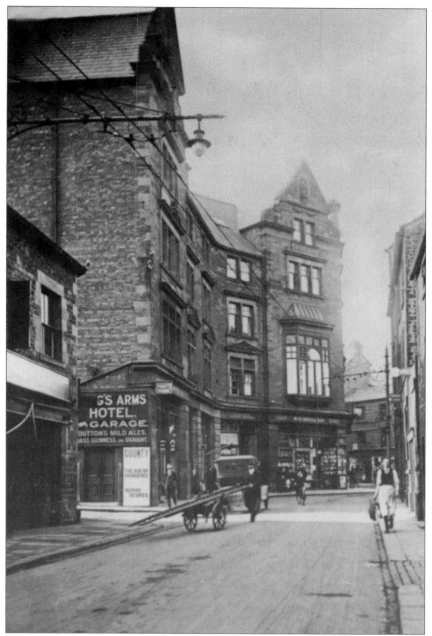

King Street with the Kings Arms Hotel, *c*. 1920. This Victorian building, of 1879, replaced an earlier inn – the most important in Lancaster. In 1689 it had fourteen bedrooms for temporary guests and special rooms for permanent residents. As the long distance coaching trade began so the inn expanded. By 1767 it had stabling for forty horses and seemed to have taken over adjacent buildings. The new hotel appears to have conformed to the old building line, giving it a complex frontage on King Street. Today the oriel window has disappeared but the view is largely unchanged.

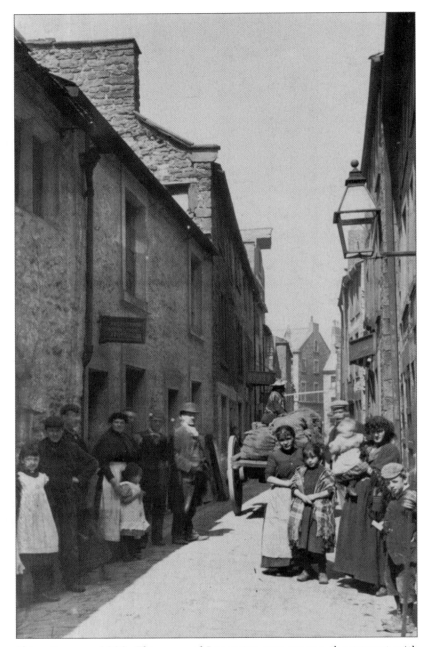

China Lane, *c.* 1893. This area of Lancaster was among the poorest with squalid housing stock, severe overcrowding and poor health prospects. The area also had a bad reputation. In August 1893 the local press reported with horror that two policemen had been attacked by a group of men in China Lane while many others looked on and did nothing. The chief constable urged that demolition plans be speeded up. Perhaps he was mindful of two benefits – clearing away unruly residents and improving the transport route. As the photograph shows the old lane had scant room for even limited traffic.

Church Street and the Judges' Lodgings, *c.* 1894. This part of Lancaster was inhabited in Roman times. The building on the right, formerly the Conservative Club, is often said to be where Bonnie Prince Charlie stayed in 1745. We believe he stayed further up Church Street. At the end is the Judges' Lodgings, Lancaster's oldest surviving house. Dating from around 1620 it was in private ownership until 1826 when it was bought to provide accommodation for visiting judges at the Lancaster Assizes. It continued to do so until 1975. Today it is open to the public as a museum. The photograph must have been taken before China Lane was widened as the last visible building on the left – the Black Bull, and the one beyond it were demolished in the scheme. The pub was rebuilt in the style of the times. It is now called the John O' Gaunt, but a scar of the old name is still visible on the corner of the building.

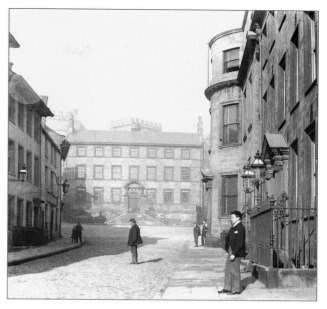

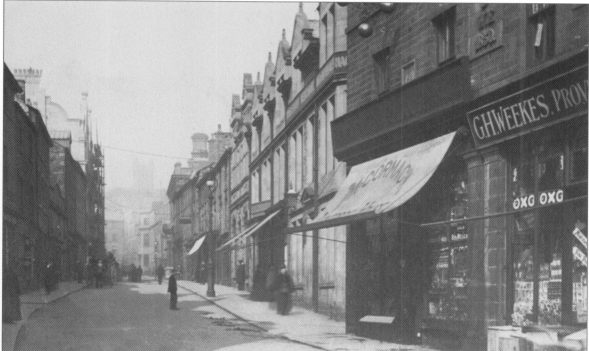

Church Street from Cheapside, *c.* 1904. The view reflects a period of prosperity with a number of new buildings replacing older ones. Just after the pawnbroker's shop on the right is the Nags Head Inn, listed in local directories from 1794. Here is the new pub building with its 1898 date stone. In the distance on the left the scaffolding is still up around the new central Co-op building, rebuilt after a fire in 1899. The building was completed in 1905. However, the presence of McCormack's pawnbrokers in one of Lancaster's prime and ancient streets does show that prosperity was not – and is not – always evenly spread.

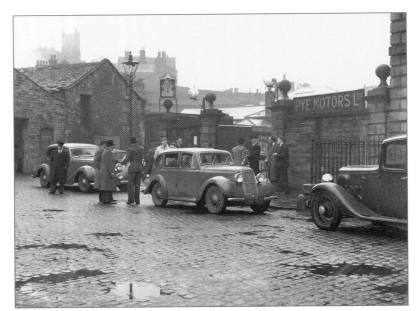

Pye Motors on Fleet Square, 1935. Brothers William and George Pye opened their garage on Fleet Square in 1925. In 1932 the firm obtained the Hillman agency, bringing the car sales side of the business into being. The photograph records a Hillman Minx that had completed a round-Britain tour of over 1,000 miles. The car cost the princely sum of £183 at the time.

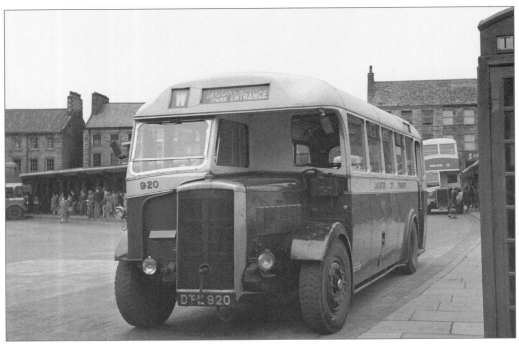

Lancaster Bus Station, c. 1950. This bus station was opened on 1 April 1939. There were four covered platforms built around the circular waiting hall, café and offices. To build it a number of streets were demolished: Fleet Street, Union Square, Union Street and one side of Damside Street were all cleared for the development. After the Second World War the fleet numbers were taken from vehicle registration numbers. No. 920 was a Willowbrook-bodied Daimler bus bought some time between 1930 and 1937. Today this site has been cleared once more to make way for a new bus station.

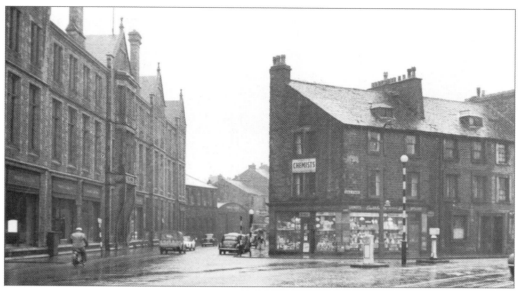

Cuthbert's Corner at the junction of Cable Street and North Road, 1962. Not surprisingly, it takes its name from the chemist and optician's shop on the corner. The business is first listed in directories in 1901. This row of buildings has been cleared and is now the site of a car park. Over the road are the grand showrooms of Waring & Gillows. These were built for Gillows in 1882, prior to their amalgamation with the Liverpool-based firm of Waring. The workshops were already well established behind this site on St Leonardgate.

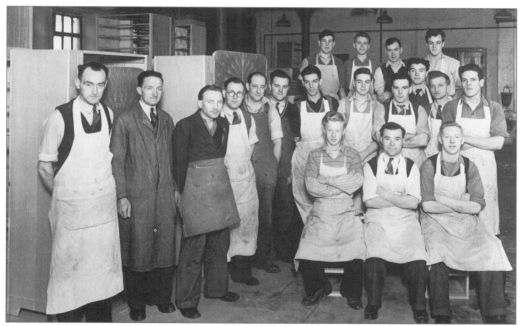

Staff of No. 5 shop at Waring & Gillows, Lancaster, c. 1950. Standing, from the left: Ernest Chudley, Joe Pearson (foreman), -?-, -?-, Jack Willacy, -?- . The firm made fine furniture in Lancaster from the late 1720s. Sadly, production ceased in 1962. This building is now in multi-occupancy.

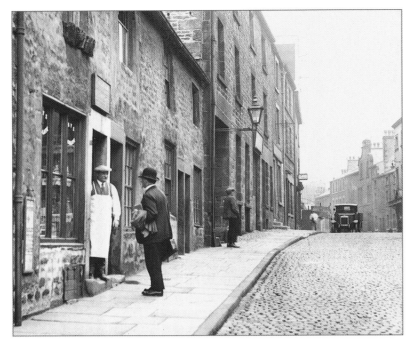

St Leonardgate with Alfred Clarke at the doorway of his shop, 1927. Clarke is listed as a yeast merchant and proprietor of a general store. He is known to have had this shop from at least 1918 to 1934. In the background the Grand Theatre is seen on the right: one of the earliest provincial theatres in the country it opened in 1782 as the Theatre Royal. During the nineteenth century it became the Athenaeum. A serious fire swept through the building in 1908 and in just seven months the Grand Theatre rose from the ashes. After a life of mixed fortunes the theatre was bought by Lancaster Footlights Club in 1951 and underwent a major refurbishment in the 1980s. Today it is a thriving theatre space in Lancaster.

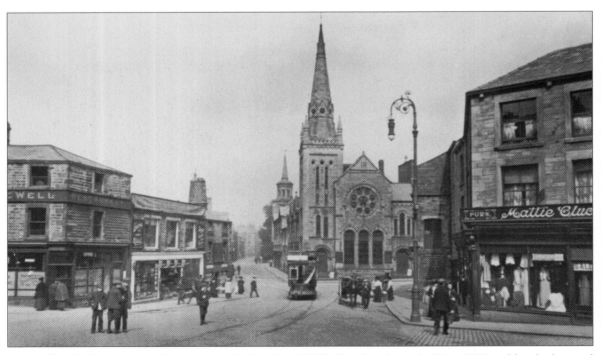

Stonewell with the Centenary Congregational Church, *c.* 1908. The church was built in 1879 and has had several uses after its closure – it is now a pub. Beyond it is the spire of St John's. To the right is Mattie Clucas' costumiers. Miss Clucas took over these premises as a going concern some time between 1901 and 1909 and was still there in 1934.

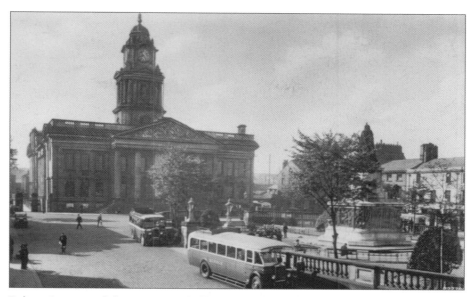

Dalton Square and the new town hall, postmarked 1937. As one of Lord Ashton's gifts to Lancaster the square was remodelled – with Queen Victoria's statue – and the civic buildings laid out, complete with fire and police stations, magistrates' court and a public hall. The new town hall was opened on 27 December 1909. Almost thirty years later the planting in the square is maturing well.

Dalton Square decorated for the coronation, May 1937. The County Cinema occupies the 1798 Palatine Hall – Lancaster's first Catholic church. It is now part of the city council's offices. Next door was the house of Dr Buck Ruxton who was hanged in 1936 for the dual murder of his wife and his maid in this property. Notice that the windows have been partially whitewashed. We believe that Canadian forces from the Pay Corps were billeted here during the Second World War.

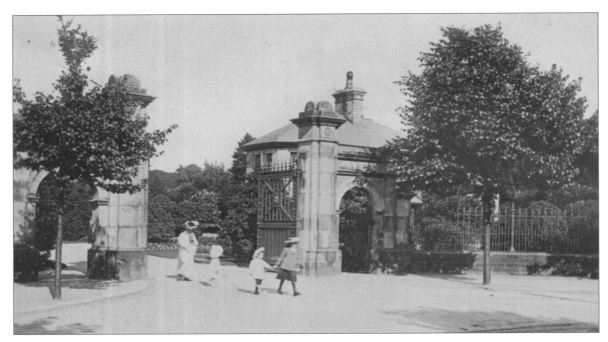

Entrance to Williamson Park, *c.* 1905. The parkland was originally moorland and quarries. Some work had been done there in the 1860s, but the Williamson family took it upon themselves to transform the area. The park was officially opened to the public in 1881 with an observatory (now lost) added in 1892.

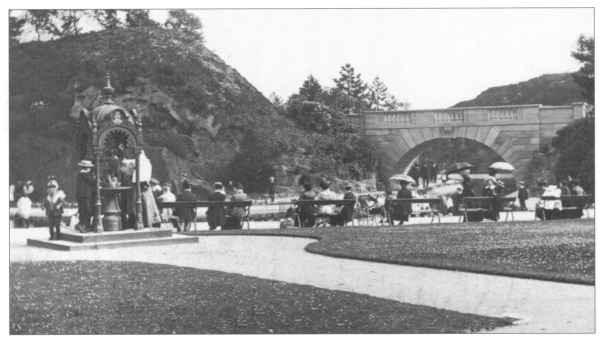

On the lakeside in Williamson Park, *c.* 1905. In 1904 Lord Ashton provided for major improvements across the park. The new bridge in this photograph replaced an earlier 'rustic' timber structure.

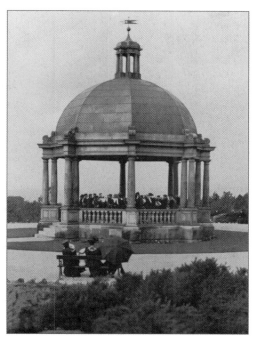

The bandstand in Williamson Park, *c.* 1905. A number of additions were made to the park at the top of the hill, including this stylish bandstand. Close by were the new palmhouse and Ashton Memorial. Unlike the other features of the park this bandstand has not survived. In 2000 its base was used to create an interactive sundial.

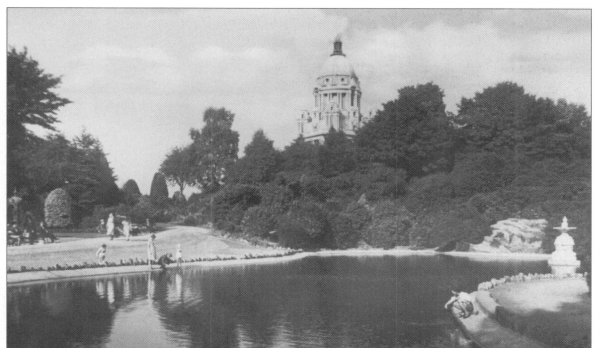

Williamson Park from the lakeside, *c.* 1935. In the distance the dramatic Ashton Memorial rises up at the highest point of the park. It was opened in 1909 as a monument to the Williamson family. The park continues to evolve. Recent refurbishment work has brought both the 'Temple' and the fountain back to life. In 1999 the park was extended with the addition of an area known as Fenham Carr.

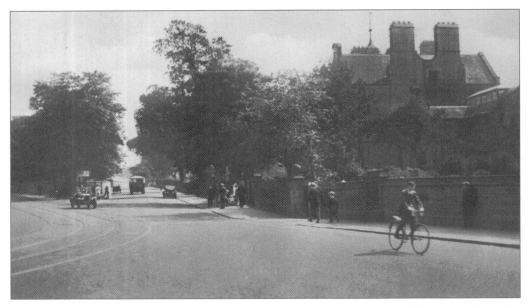

The junction of South Road and Ashton Road with the Royal Lancaster Infirmary to the right, *c.* 1920. The hospital was built in one corner of the grounds of Springfield Hall and was opened in 1896 by the Duke and Duchess of York.

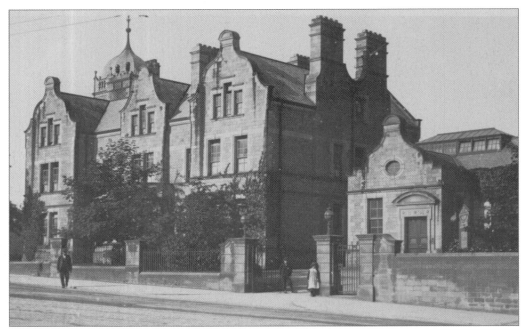

The Royal Lancaster Infirmary photographed by George Howarth, *c.* 1905. The costs of this new hospital were raised by subscriptions and fundraising events launched in 1880. Having given the largest amount towards the building the foundation stone was laid by Lord Ashton in 1893. In 1938 the Springfield Hall estate was bought and the villa was demolished in 1962. The hospital continues to expand across the site.

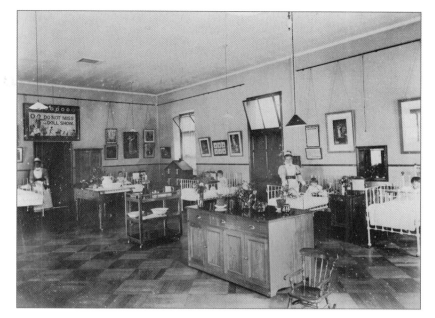

The Children's Ward, Royal Lancaster Infirmary, *c.* 1897. There were to be sixty beds in the new hospital but, on opening, only forty were available. Fundraising for day-to-day expenses was continuous until the establishment of the National Health Service. All but the destitute were asked to pay for their treatment.

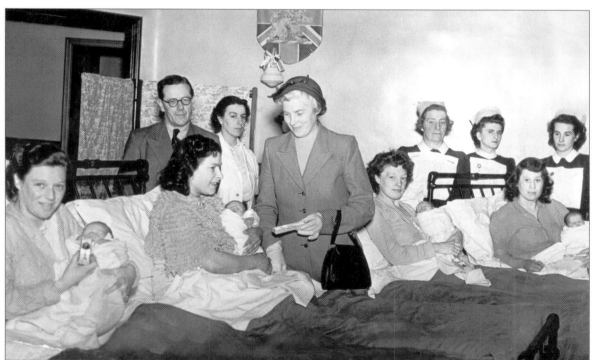

Coronation Day babies at the Royal Lancaster Infirmary, being presented with commemorative teaspoons, in 1953. The trend away from home births to hospital births was dramatic during the twentieth century. In 1928 only 14 of the 649 babies born in Lancaster were delivered in one of the local institutions. In 1976 the new maternity unit opened at the Royal Lancaster Infirmary, and in 1997 some 1,684 of the district's 1,715 babies were born there.

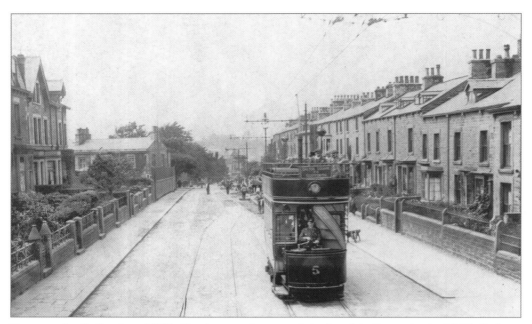

Tram on South Road, *c.* 1908. The tram system was introduced to Lancaster in 1903. Perhaps bowing to the inevitable, in 1911, the open-topped cars had roofs fitted. The service only ran until 1930. It seems the town was too small to sustain the costs of the system. The building at right angles to the road, on the left, is Southfield, now part of the Royal Lancaster Infirmary site.

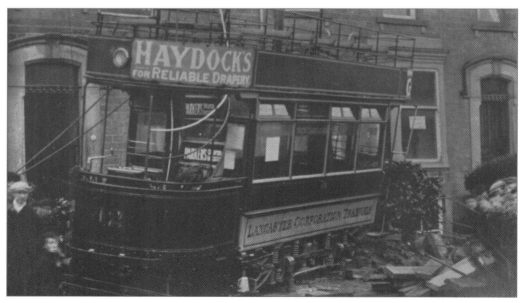

Runaway tram on South Road, February 1910. On an early Saturday morning the tram, with twenty-four passengers on board, ran down the hill from the Park Hotel gathering speed towards the Pointer. Here it left the rails, crossed the road and dashed through the wall and railings into the front gardens of houses on Spring Bank, South Road. No-one was seriously hurt although the front of the tram and the garden walls were badly damaged.

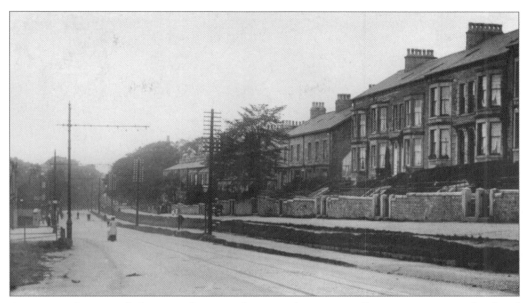

Greaves Road, postmarked 1910. This part of Greaves, known as Belle Vue Terrace, was developed gradually through the nineteenth century. The houses vary in size and design and the last run, in the foreground, was completed by 1893. The decorative railings dividing the properties from the roadway had not yet appeared. It is difficult to imagine a time when it was safe to push a baby along the middle of the road!

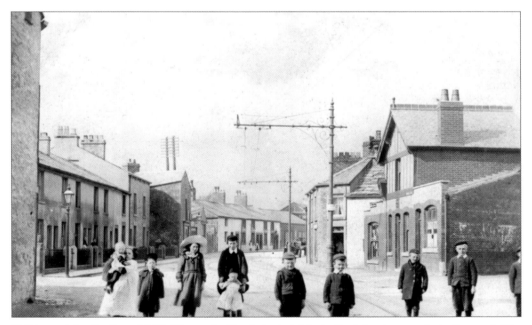

Children at Scotforth, c. 1908. The post office is just visible to the left, at an angle to the road. The building opposite, with its door open, was a grocer's shop run by Mrs Hannah Andrews. Much of Scotforth was incorporated into Lancaster's boundaries in 1900, and three years later, it became the southern terminus of the town's tramway system.

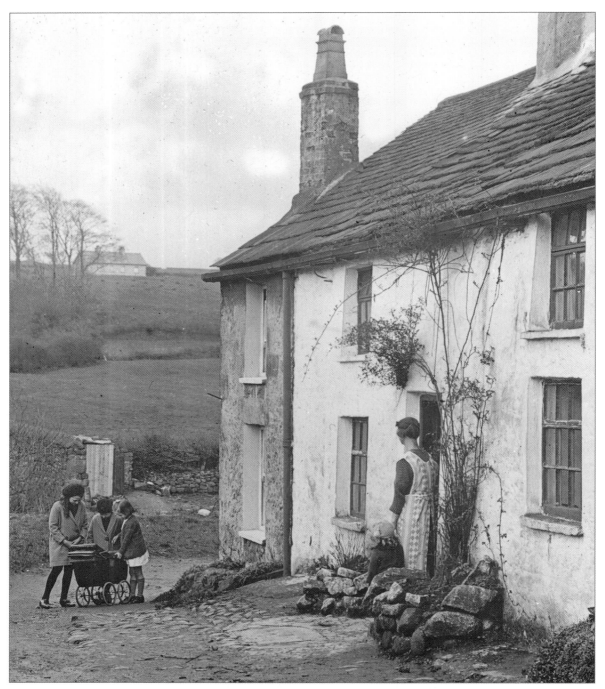

Mrs Duggan at Moorside Cottages, off Barton Road, Scotforth, photographed by Sam Thompson, *c.* 1927. Gathered around the doll's pram are Margaret and May Thompson (nieces of the photographer) and Mrs Duggan's younger daughter. Just alongside this run of cottages stood the cattle-shed for James Thompson's farm. This is now the Barton Road Community Centre. His house, the farmhouse, stands opposite. The cottages were demolished in December 1938.

3

Around Morecambe

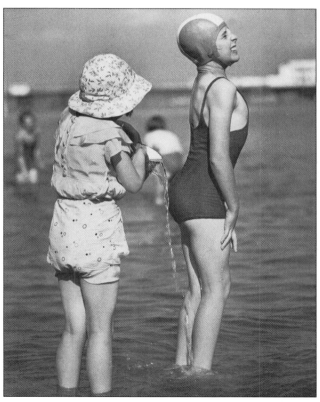

Children near Central Pier, Morecambe, photographed by
H.T. Morris and captioned 'Coo . . . it's cold!!', *c.* 1935.

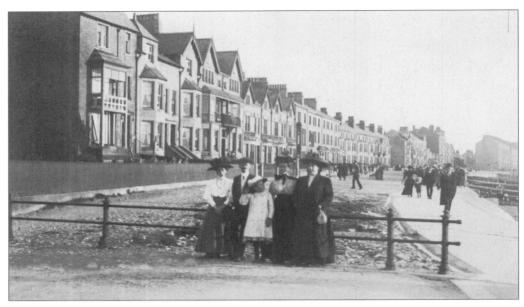

Sandylands Promenade, *c.* 1908. A great many of these properties were used as apartments or boarding houses for visitors. Way off in the distance – on the extreme right of the photograph – is the Grosvenor Hotel. Built in 1899, it added grandeur to this section of the promenade. In the Second World War it was taken over as office space for National Savings staff evacuated from London. This area suffered markedly from storm damage, especially in the winters of 1907, 1925 and 1927.

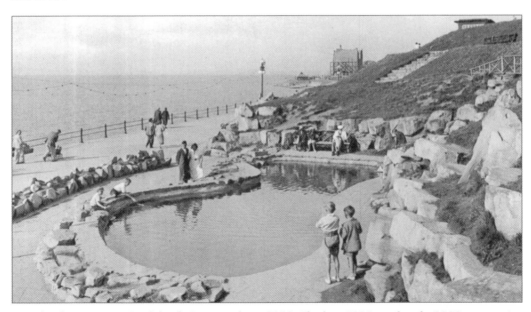

New developments on Sandylands Promenade, *c.* 1932. The late 1920s and early 1930s saw major investment in Morecambe's sea defences and visitor attractions. A new promenade at Sandylands, from the Battery to the Grosvenor Hotel, was opened in April 1930 and the Sunshine Slopes opened the following year. Presumably this photograph was taken soon afterwards.

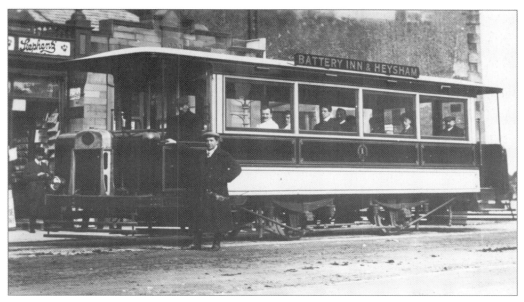

Morecambe tram at the Battery Inn, *c.* 1912. This card boasts England's first petrol tram. The tram route was short – from the Battery to the Strawberry Gardens at Heysham – and the early fleet was small consisting, initially, of three trams. This petrol tram service began in 1912 and ran until 1924 when buses took over. The Battery Inn was built in 1875 and was extended in 1899. To do this the old windmill had to be demolished.

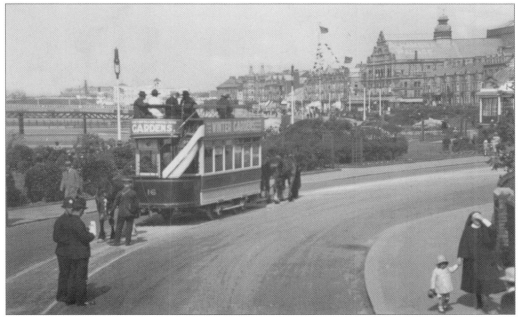

A view from the Battery along West End Prom, postmarked 1926. The horse tram service was launched in June 1887 by the privately owned Morecambe Tramways Company. In 1909 the corporation took over all but this short route. The visitor attractions roll out along the prom from here. Most visible is the Alhambra standing directly opposite the West End Pier.

The Alhambra, postmarked 1907. The elaborate entertainment hall was designed by Herbert Haworth and opened in 1901. In its early days novelty acts were often playing although serious events were also to be found. Adela Pankhurst, for example, addressed a meeting there on Votes for Women in 1908. On Sundays, the Alhambra held sacred concerts. In 1927 the building became a cinema and, three years later, was renamed the Astoria. The building was severely damaged in a fire in 1970. It is now called the Carlton Inn.

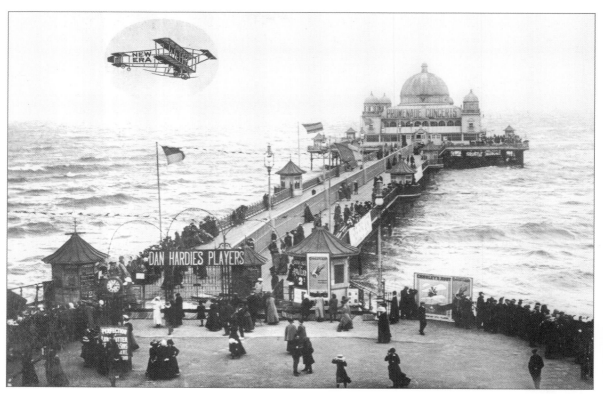

West End Pier, c. 1908. This was the younger of Morecambe's two piers. It was opened in 1896 and such was its success that an extension was added two years later. The piers were always in competition with each other to attract visitors with shows, dancing and events to suit all tastes. One of the many posters at the pier entrance, here, advertises performances of *Charley's Aunt*. This pier continued the tradition of 'end of the pier' shows – with the Royal Follies – until the late 1960s. It was the first pier to be lost in the great storms of 1977.

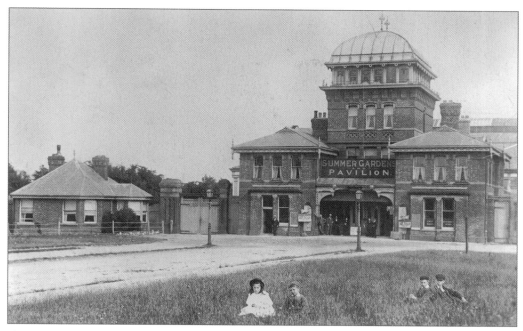

The Summer Gardens Pavilion, *c.* 1893, photographed by Fred Cawsey, we suspect, shortly before closure. Built in 1878 the Summer Gardens had a boating lake, bowling green, racecourse and ballroom. Its location, away from the promenade, may well have been its downfall especially as the first phase of the Winter Gardens – or People's Palace – followed fast on its heels. It was sold in 1898 and by the following year part of the site was being developed. Regent Road, close to its junction with Balmoral Road, appears to have driven straight over the pavilion site.

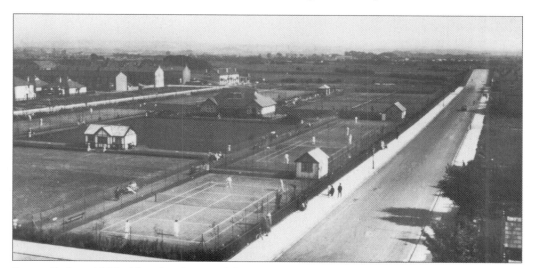

Regent Park, *c.* 1930. After the closure of the Summer Gardens most of the site seems to have been left derelict. In 1924 the land was bought by the corporation and work began to convert it into Regent Park. It was opened on 17 July 1926 by the Lord Mayor of Bradford – which seems appropriate for a town that was known as Bradford-by-the-Sea because of the large numbers of Bradford holiday-makers that came to Morecambe.

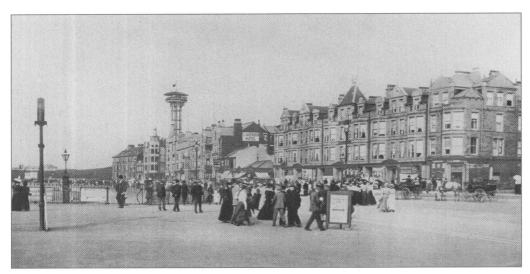

West End with Warwick's Revolving Tower, *c.* 1903. This new attraction – named after the designer – was built in 1898. The lift could hold 200 passengers as it took them up and around the outside of the steel tower. The viewing pavilion was static and was reached by a short flight of steps from the lift. It stood some 155 ft high and, no doubt, offered splendid views of the bay. Why then did the attraction fail? It was sold in 1903. However, the building below the tower did have some success as a cinema – Morecambe's first film theatre – and as a roller-skating rink. It became known as The Whitehall.

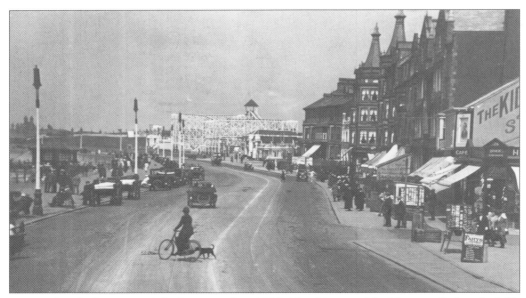

West End with the Figure Eight Fairground, *c.* 1910. The fairground had been walled cattle fields taking stock landing at the Stone Jetty before being sent to market. Morecambe had no cattle market of its own; much of the livestock came from Ireland. Once the port had moved to Heysham Harbour new tracts of land, like this, were available for tourism developments. The Figure Eight was a major attraction until the late 1930s when the new Cyclone big dipper ride took over. The site was redeveloped as the Empire Buildings, and opened in the early years of the Second World War.

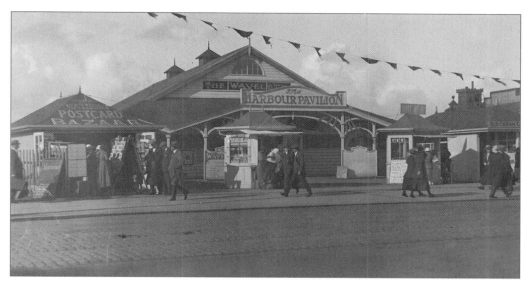

The Harbour Pavilion, *c.* 1919. Morecambe boasted many concert parties. At first performances were only allowed on the sands, but troupes quickly became linked with piers and pavilions across the resort. Originally an open-sided shelter, the Harbour Pavilion was gradually transformed into a small theatre. The photograph shows the recently enlarged performance space with its accompanying seaside commerce. It was demolished after the summer season of 1932 for the new Harbour Band Arena.

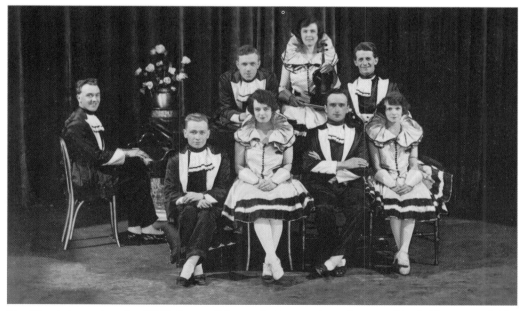

The Wavelets as pierrots, 1925. Some of the earliest concert parties were Hart's Pierrots and The Merry Japs. The Wavelets troupe was formed in 1914 by Harry Marsden and Jess Haigh. It continued to entertain the crowds in Morecambe until the closure of the Pavilion in 1932. Members of the troupe had many elaborate costumes, but were not averse to reviving the fashions of the turn of the century.

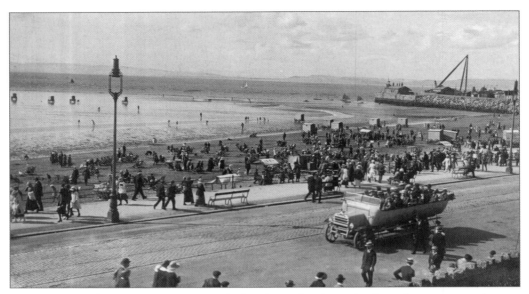

The prom near the Stone Jetty, *c.* 1910. A charabanc plies its trade along the prom as swimmers and paddlers enjoy the sea in the shadow of Ward's shipbreakers. Notice the bathing machines on the sands and in the water. These contraptions were invented in Margate, in 1753, by Benjamin Beale. They were designed to help with the growing interest in seabathing for health purposes at a time when the nation had a strong belief in bodily modesty. Locally they were known as 'vans'.

Vans and their staff, *c.* 1900. In 1853 there were eighteen vans on the front at Morecambe. Originally men bathed in the nude and women wore bathing costumes. No wonder the local paper warned, in 1877, that anyone bathing in front of a private house ran the risk of arrest and prosecution. Sunday bathing was also frowned on. While you changed in the van the horse would pull it into the sea, until the floor was just out of the water. The swimmer could then slip into the sea unseen.

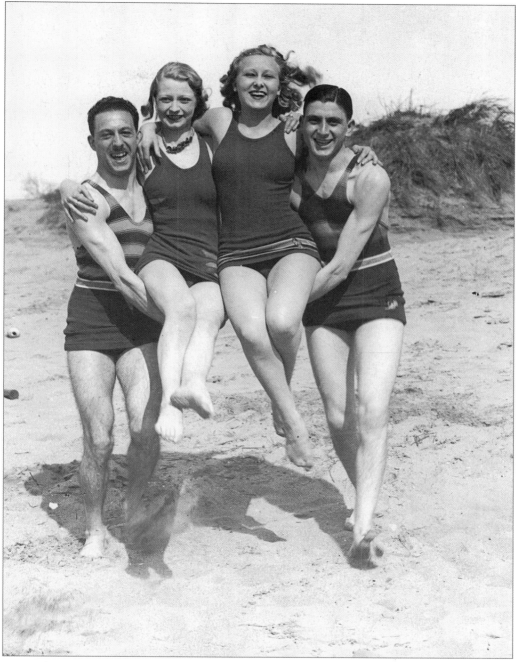

Having fun on the sands, *c.* 1930. As the seaside holiday became more popular swimming became a pleasure rather than a medicinal cure. Even so, the corporation tried to prohibit mixed bathing throughout the day – except from vans – until 1911. After the First World War young men and women expected far greater freedom than their parents had enjoyed. Fashions had changed and the body was no longer covered or hidden. The idea of the fair-skinned 'English Rose' was gone. Suntans and outdoor sports were all the rage.

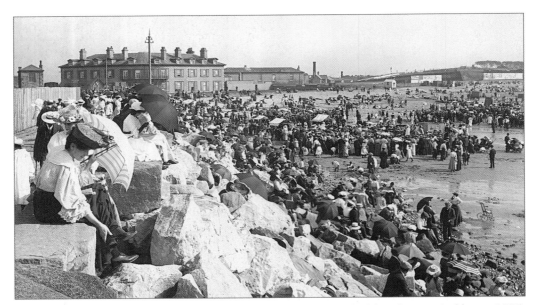

The rocks with the Midland Hotel in the background photographed by Thomas Ambler, *c.* 1905. This was built in 1849 to the designs of Edmund Sharpe and Edward Paley. It served as the railway hotel for the new line to the resort and was originally known as the North Western Hotel. The Promenade station, however, was not built until 1907. The hotel was swept away for a dramatic, modern, streamlined successor.

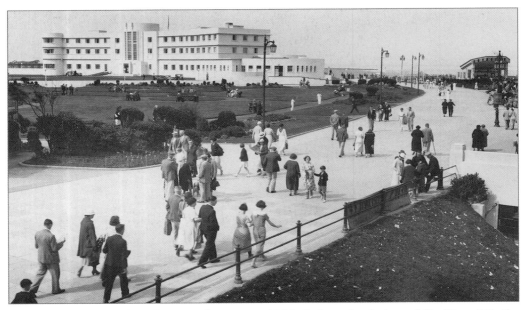

The Midland Hotel and Harbour Band Arena, *c.* 1935. Built to the designs of Sir Oliver Hill, the new hotel opened in July 1933. The height of fashionable art deco design, the building incorporated the work of well-known modern artists and craftspeople such as Eric Gill, Eric Ravilious and Marion Dorn. In the Second World War the building was requisitioned for use as a Royal Air Force Hospital. Since then its fortunes have been mixed and it is currently on the market.

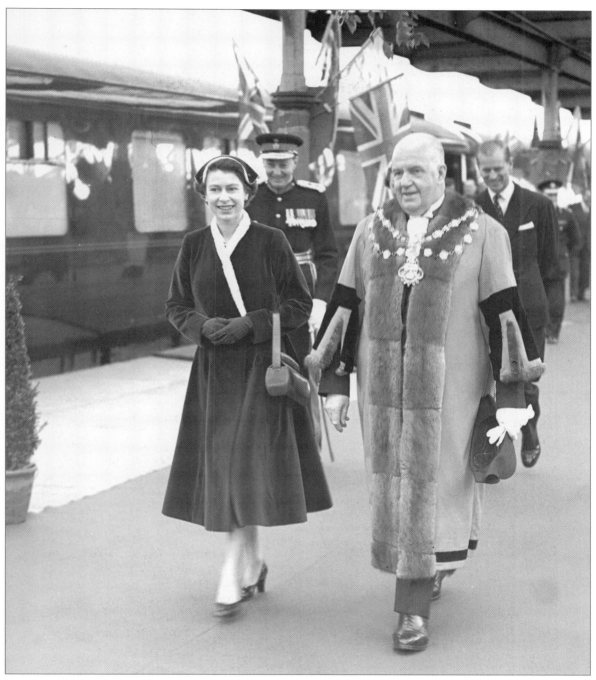

Queen Elizabeth's arrival at Promenade station on 13 April 1955. This was a fleeting visit to the resort on her way to Lancaster, Preston, Southport and Blackpool. There was only time to meet local dignitaries on the forecourt. It was the Queen and the Duke of Edinburgh's first visit. Indeed, the local press pointed out that this was the first royal visit to Morecambe. George V and Queen Mary had been close when they visited the White Lund Filling Factory in the spring of 1917.

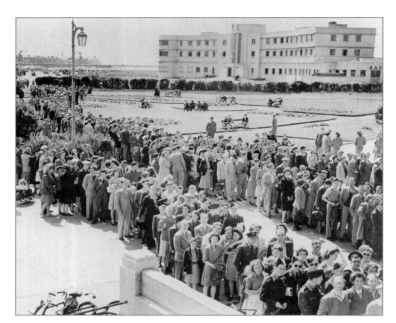

Crowds outside the Super Swimming Stadium in 1945, queuing for the Bathing Beauty Contest. The event began as a promotion for the pool to bring in the crowds. It certainly succeeded. Originally the heats were run throughout the season – from June to August – on Wednesday afternoons. A huge crowd, reputedly over 5,000 people, attended the first heat when Audrey Battersby of Morecambe won first prize. The Midland Hotel stands out proudly in the background.

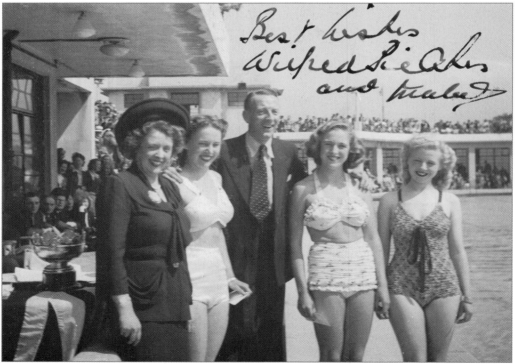

Wilfred and Mabel Pickles and some of the Bathing Beauty competitors, June 1947. Judges of the heats and finals were often drawn from the world of entertainment. Some, like George Formby, Joe Loss and Bob Monkhouse were asked back to repeat the 'task'. However, things did not always go smoothly with the competition judges. In 1962 Hughie Green sued the corporation for damages caused to his suit when he fell in the pool. The case was settled out of court.

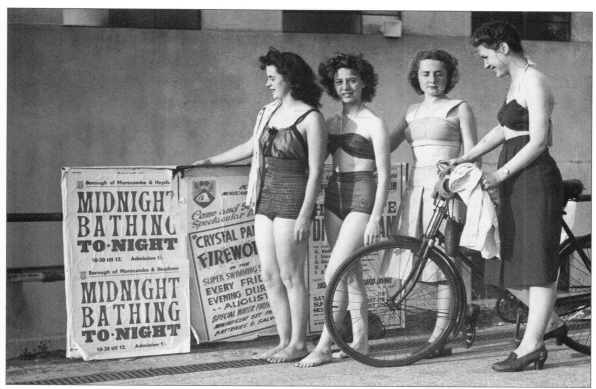

Late night swimming at the Super Swimming Stadium, *c.* 1949. The late night opening of the pool seems to have been a popular event. Around 10,000 people attended in the first week! As the posters show, the pool was also the venue for other events – fireworks, water ballets and diving displays were all popular.

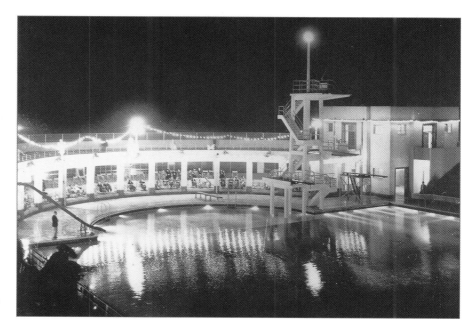

The Super Swimming Stadium by night photographed by G.M. Shackleton, *c.* 1938. Its dramatic, modern, art deco style fitted well with its close neighbour, the Midland Hotel.

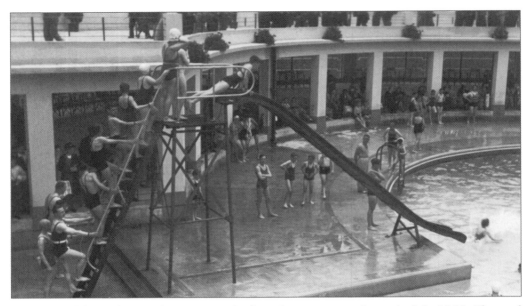

The water slide at the Super Swimming Stadium from a postcard sent in July 1937. The pool opened on 27 July 1936. At 110 yds long it claimed to be the biggest outdoor pool in Europe. This card was sent home to Glasgow and noted that they were 'having a fine time here. Grand weather. Grand digs and grand food. Swimming pool heated to 70° – too low for me!'

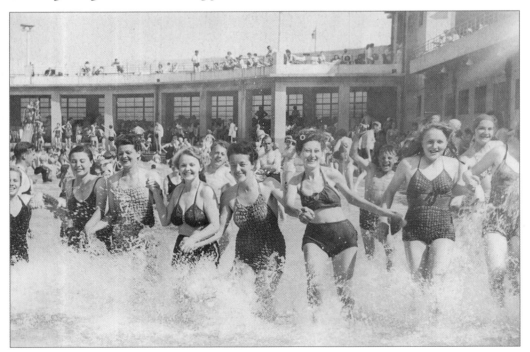

Bathers at the Super Swimming Stadium, c. 1948. The pool could take some 1,200 bathers and 3,000 spectators at any one time. There were group sessions for younger swimmers that look – in the photographs – something like junior aqua-aerobics.

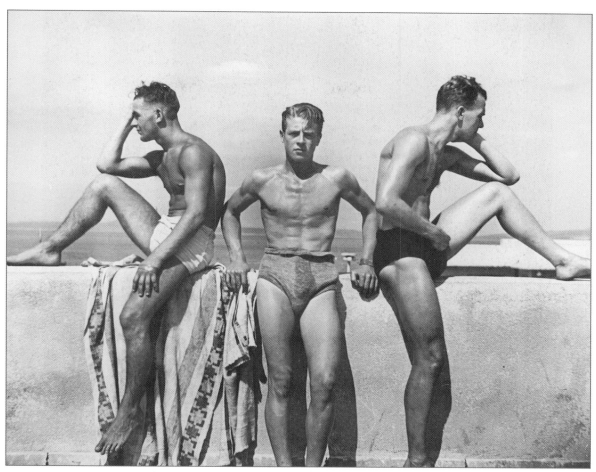

Soaking up the sun at the Super Swimming Stadium, summer 1938. The pool was a major attraction for holidaymakers and locals alike. As well as swimming and sunbathing facilities, the baths soon had diving displays and aqua shows – not forgetting the bathing beauty contests. These three men were divers at the SSS. On the left is Malcolm (Mac) Martin, founder of the 'Diving Aces'. In the 1960s hopes to improve the pool, by roofing it over, came to nothing. It was clear that major repairs were needed. The premises closed in 1975.

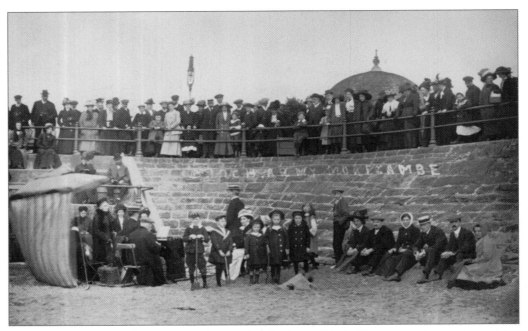

The Church Army performing on Morecambe Sands, *c.* 1905. This was a favourite spot for performers, especially concert parties such as the Merry Japs. A large audience could always see the 'show', whatever its nature, from the Central Promenade. Here the music is provided by a portable harmonium. No doubt hymns and uplifting songs were the order of the day.

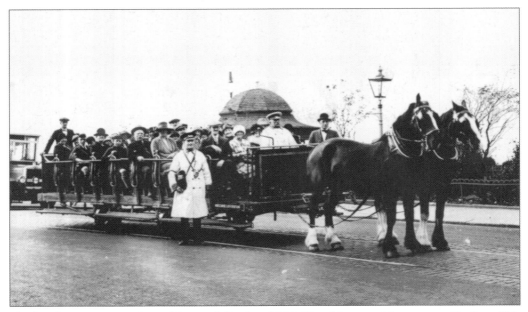

The last horse tram on Central Prom, 4 October 1926. The driver on this run was Mr Grey. This service plied its trade from the Battery to Bare. Both double-decker and single-decked 'toast rack' trams (as seen in this view) were used on the route. Buses were gradually introduced from August 1919 onwards, but did not fully replace the tram service for another seven years.

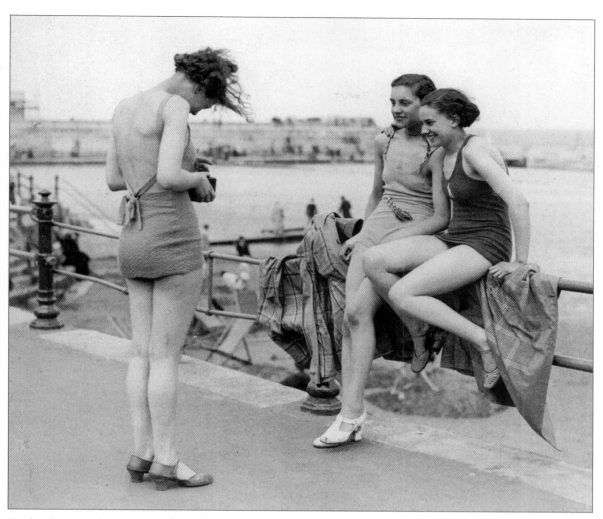

'Smile please . . .' – photographing friends on Central Prom, *c.* 1938. Many young people felt that, by holiday time, they had earned the right to let their hair down and have fun. The resort provided countless opportunities for entertainment whatever your interests; dancehalls, cinemas, variety shows, fairgrounds, swimming and maybe even a suntan too. It looks a little windy in this photograph and some people on the beach seem to be wearing overcoats!

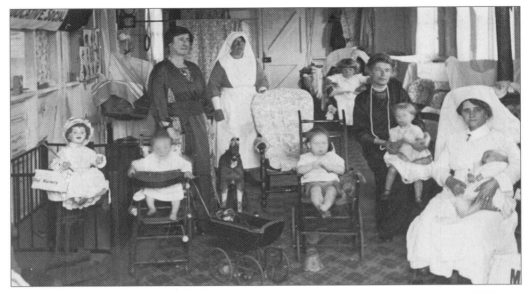

Morecambe Day Nursery, 1921. This photograph shows a nursery set up to provide child care facilities for visitors – the Morecambe Excursionists' Day Nursery – which opened on the Figure Eight Fairground on 15 June 1920. Today's Morecambe Day Nursery stands on Station Road just opposite the school. It opened during the Second World War to support families – especially mothers – going into war work. Although some twenty years apart in age the prefabricated buildings of the two nurseries are almost identical.

A class at Euston Road school, c. 1926. The school was opened in 1902 by Dr Watterson, Medical Officer of Health for Morecambe. It was designed by a local architect, Percival B. Rigg of Skipton Street. The teacher in the white blouse is Miss Olive Firth. The school is still very much in use today, but is now known as Morecambe Bay County Primary School.

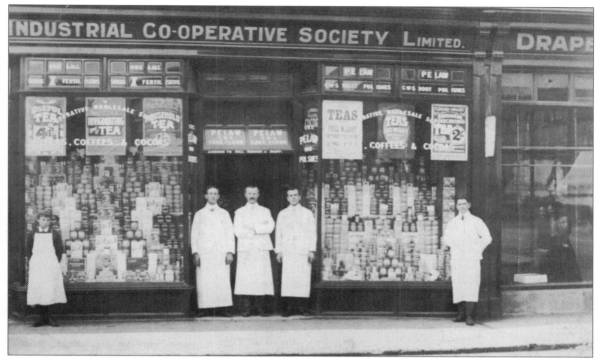

Outside Queen Square Co-op, *c.* 1910. Standing in the middle of the doorway is W. Rawes, the manager. Morecambe's first branch of the local Co-op – the Lancaster & Skerton Equitable Industrial Co-operative Society Ltd – opened in Pedder Street in 1867. Around thirty years later it was replaced by this new Queen Square branch where the young Dame Thora Hird worked for some time as a cashier.

A reluctant donkey rider, Central Prom, *c.* 1948. Back to the sands and one of the well-known beach attractions of the resort. William Woodhouse (1857–1939), perhaps Morecambe's best-known artist, painted several scenes of donkeys and their attendants. Today rides along the sands are still possible, but ponies have taken the place of the donkeys.

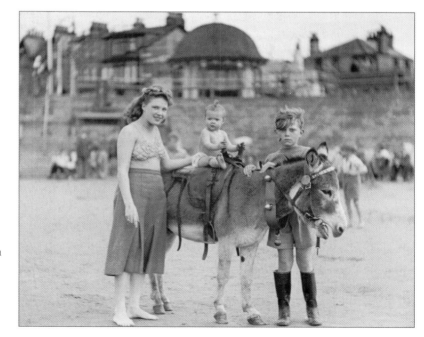

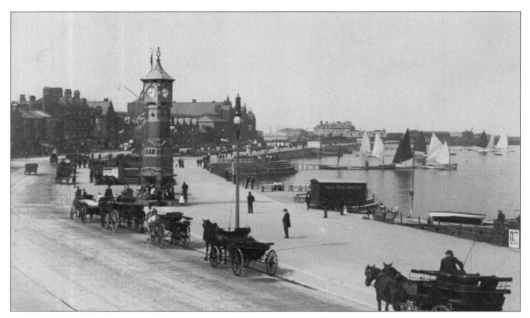

Central Prom with the new clock tower in the foreground and the Winter Gardens beyond, *c.* 1908. The tower was a gift from Morecambe's Mayor, J.R. Birkett. It was built to the designs of architect Charles Cressey who was also responsible for the Bank of Liverpool building on the corner of Euston Grove. The foundation stone was laid on 24 June 1905. The clock tower replaced the Albert Lamp, erected, in around 1863, in memory of the Prince Consort who died in 1861. There was a byelaw prohibiting the tethering of donkeys to the lamp!

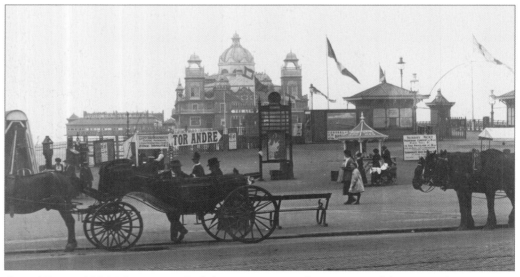

Central Pier, *c.* 1915. The pier was built between 1868 and 1869, around five years after Blackpool Pier, in the expectation it would attract more visitors to the resort. It probably succeeded, as it was extended in 1871 and was given a dramatic pavilion in 1898. Referred to locally as the Taj Mahal, this pavilion was also the work of Charles Cressey. It soon became a regular haunt of variety troupes like The Ideals and, after 1916, The Poppies.

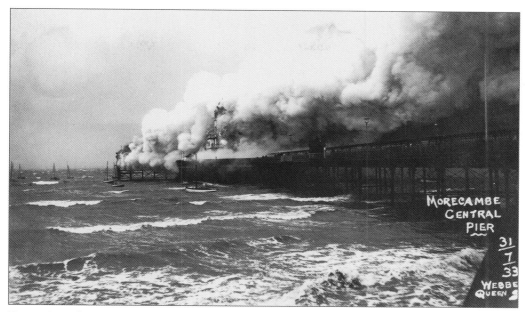

Fire at Central Pier, 31 July 1933. The blaze began underneath the skating rink at nearly 5.30 p.m. Luckily it was boarding house teatime, so the pier was largely deserted. The fire was fanned by high winds and spread quickly. By 6.00 p.m. the whole pavilion seemed ablaze and before long the central dome had crashed in. An hour later the pier was a blackened, twisted ruin. It seems that some of the girders had melted in the intense heat. There were fears that burning fragments blown across town would put other buildings at risk.

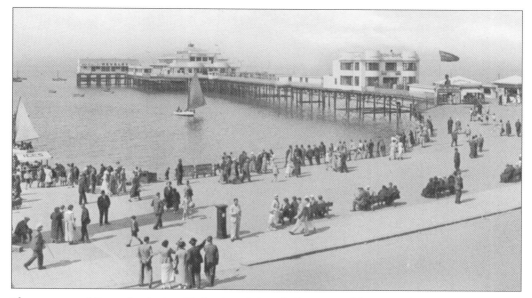

The owners of the ruined pier, Herbert and Joseph Procter, sold out to the New Central Pier Company. Two years after the fire modern, art deco pier buildings stood out on the Victorian structure. There was a dramatic café at the entrance, an outdoor dance floor and a vast pavilion at the end of the pier that could accommodate 2,000 dancers.

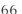

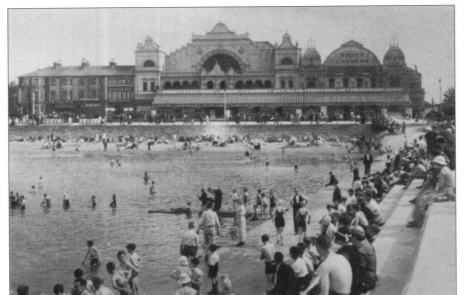

The Winter Gardens and Victoria Pavilion from beyond the paddling pool, *c.* 1935. The Winter Gardens building (on the right) was opened in 1878 as the People's Palace. It was demolished just over a century later. The Victoria Pavilion on the left was built in 1896. After a long period of closure, recent renovation work has rendered the pavilion structurally sound. It is now in good shape for future projects.

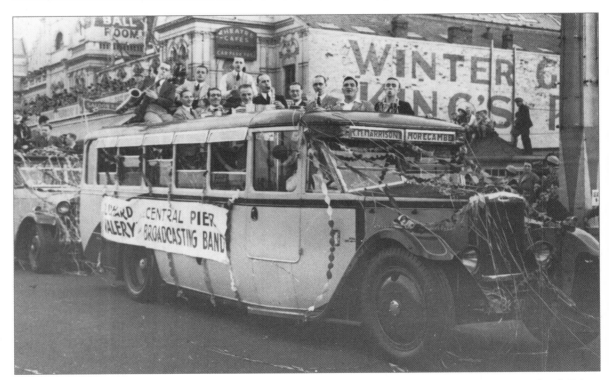

Richard Valery and the Central Pier Broadcasting Band outside the Winter Gardens, *c.* 1936. Richard Valery played the accordion and was accompanied by fourteen other talented musicians for his Pier concerts. Here they are taking part in Morecambe's popular carnival parade. The origins of the carnival lay in the peace celebrations held after the First World War. However, as it was held in September it became one of the many ways of extending the holiday season.

The Winter Gardens by night, *c.* 1937. By this time the illuminations had become a tradition in Morecambe, starting towards the end of the season as the nights were drawing in. The initial launch date of this evening attraction is not known. Buildings were certainly lit up with candle fairy lights in the early 1900s.

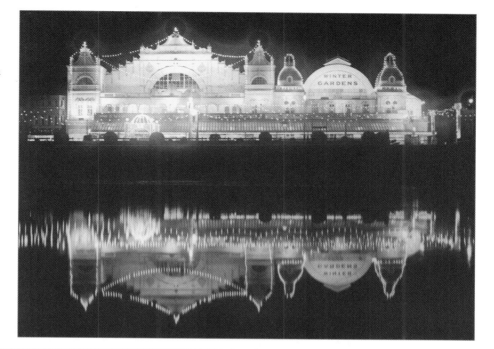

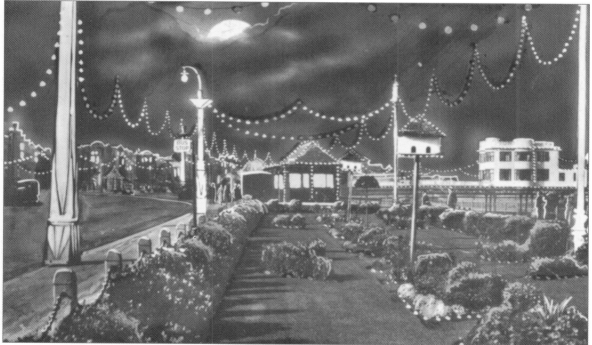

The Central Prom, by night, with the pier café on the right, *c.* 1937. Once the new power station on Caton Road opened in 1924 the illuminations could run on a far greater scale. Two years later, fears that the General Strike would ruin the illuminations through lack of coal for the power station were put to rest with a visit to the Coal Controller in London.

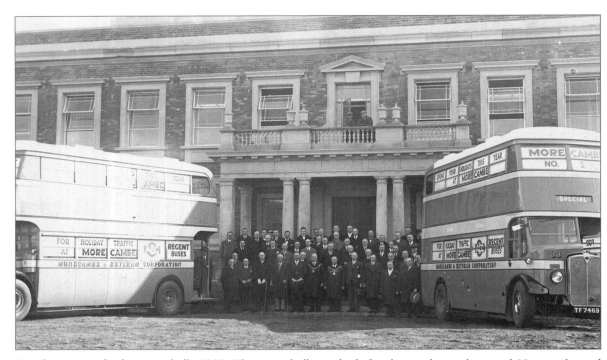

New buses outside the town hall, 1932. The town hall was built for the newly amalgamated Morecambe and Heysham Corporation. It took some time to decide on the location but after four years it was opened by the Lord Mayor of London on 7 June 1932. This photograph records two of the six new buses – AEC Regents bodied by Weymann – that brought the local fleet up to date. Another thirty-two buses were added over the next six years. Some even had roll-back 'sun saloon' roofs.

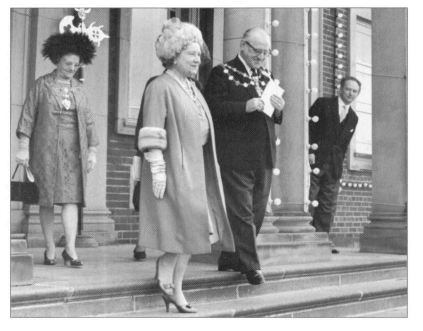

Queen Elizabeth, the Queen Mother, at Morecambe Town Hall, 16 November 1967. In just an hour the Queen Mother visited the town hall and opened the Rainbow Centre on Clarence Street. She then travelled on to Lancaster to open officially St Martin's College. Crowds lined the prom to greet the royal visitor, including 2,000 local schoolchildren. As she left the town hall the Queen Mother was presented with a carton of Morecambe shrimps.

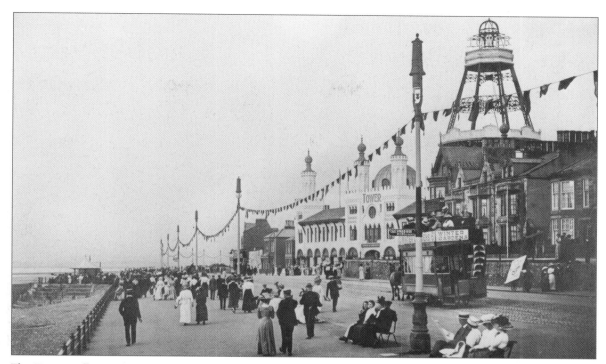

The Tower Ballroom, *c.* 1908. The elaborate tower, the central feature of the complex, was never fully achieved and was removed in about 1918. There was a concert hall, theatre, ballroom and roller-skating rink as well as gardens decked with fairy lights to stroll in. In 1925 the buildings were modernised. The theatre/cinema could take 2,300 seated with room for 1,500 standing. Within five years a plush dress circle had been added.

The carnival outside the Tower, *c.* 1930. Although very popular, the September carnivals were brought to a close in 1937 after financial losses. However, the week-long event was reborn as a single day celebration in 1962. Notice the shops in front of the Tower. There were ten shop units laid out for rental by small traders.

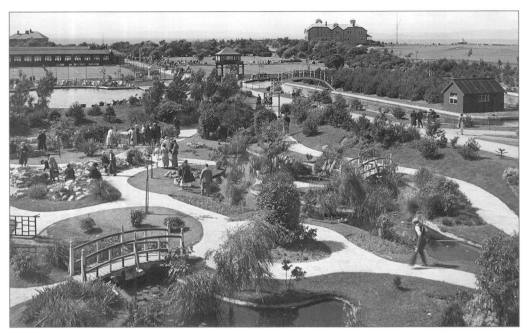

Happy Mount Park with its 'midget motor speed track' to the right, *c.* 1936. The park originally boasted tennis courts, a bowling green, a band arena and a pool, as well as pleasant pathways and avenues to stroll through. The land was the gift of Mr Henry Wood, a former councillor, who was invited to perform the opening ceremony on 2 June 1927. This view shows one of the mid-1930s improvements – the new Japanese gardens.

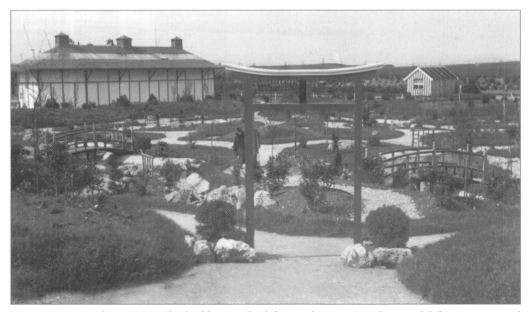

Happy Mount Park, *c.* 1936. The building to the left was the new 'monkey castle', housing around 100 monkeys. These – and the miniature golf – were, like the gardens themselves, some of the 1930s additions to the park.

4

Around Heysham

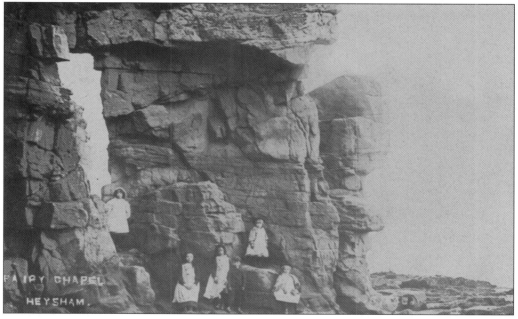

A natural rock arch at Heysham Head known to generations of children as the Fairy Chapel, photographed in about 1907.

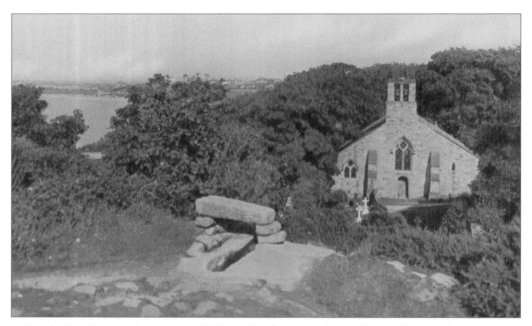

St Peter's Church from the vicinity of St Patrick's Chapel on the headland. The church is of ancient foundation (perhaps contemporaneous with the chapel) and certainly includes Anglo-Saxon and Norman-period architectural features, a fourteenth-century chancel and a south aisle built in the fifteenth century. There were many later alterations. Such an ancient site also has a wealth of stone carvings, notably a very finely preserved base of an Anglian preaching cross and a hogback stone – a Viking burial stone (below) – depicting mythical scenes and figures, which is now on display in the church.

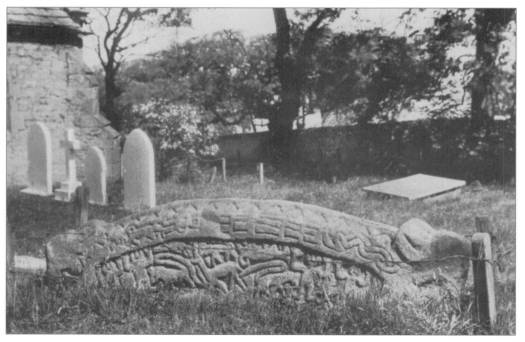

Bailey Lane in Heysham village, *c.* 1900. The village, beside the sea, was also known as Lower Heysham and this is where a number of farming and fishing families lived. In 1870 Edward Baines described it as a cluster of 'poor houses' built of rough stone similar to Greese House in the centre of this picture, a seventeenth-century building which probably became the rectory when the Clarkson family arrived in 1735.

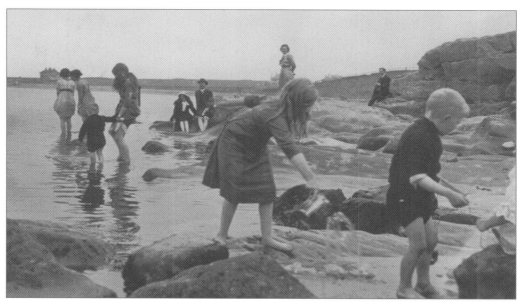

The rocks on Heysham Head were a popular attraction for holidaymakers wanting a paddle, as in this photograph, *c.* 1910. To the left is Bay Cottage, or South Cottage, which was once an inn. It was very exposed on the shoreline, and was badly damaged by storms and eventually demolished.

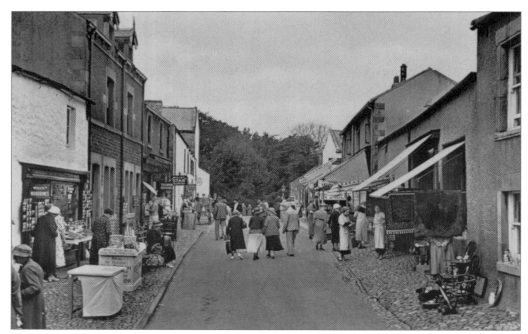

The quaint and attractive Main Street in Heysham has always been a magnet to tourists, encouraged by the many little shops and stalls which appear during the summer season. The Royal Hotel also had its following, but the drink particularly associated with the village has been nettle beer, a local speciality. The village had been home to small farmers and fishermen for generations and horse-drawn carts (below) were a common sight up to the mid-1900s. They were used by fishermen to carry home mussels from the rocky outcrops (skears) offshore and many types of fish from the traps set on the foreshore close by.

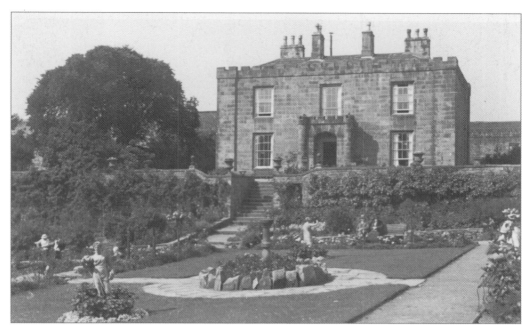

Heysham Head Hall and grounds became a well-loved tourist attraction during the early twentieth century. It proclaimed itself to be 'The Wonderland of the North' and the centrepiece of the extensive wooded grounds was the Old English rose garden (below). The hall was built before 1820, but it is supposedly on the site of a thirteenth-century manor house. With the building of nearby Heysham Harbour in 1904 the area's appeal was tarnished in the eyes of many local gentry who looked for rural retreats elsewhere. Heysham Head was sold and became a private hotel before it was developed as a pleasure garden featuring such delights as a menagerie, open-air concerts and Teddy the caged Russian bear.

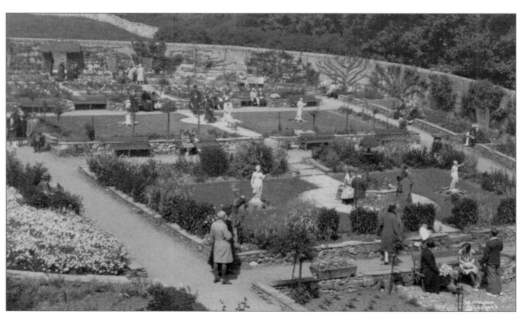

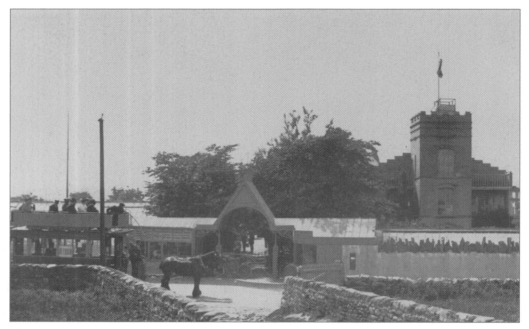

The Strawberry Gardens is best known today as a public house on Heysham Road, Heysham. Few are aware that it was once a tearoom set in a real strawberry garden. It was ideal as a destination for holidaymakers staying in Morecambe and was conveniently connected by a horse-drawn tram service. The gardens were located in the attractive countryside between the two towns and were opened in 1875 by James Aldren. They had extensive orchards and flower beds as well as soft fruits, together with see-saws, swings, tennis courts and a croquet lawn, all available on payment of an admission fee of 2*d* for adults and 1*d* for children. By the end of the century the gardens were being jostled by newly built houses, but they remained very popular until the 1920s.

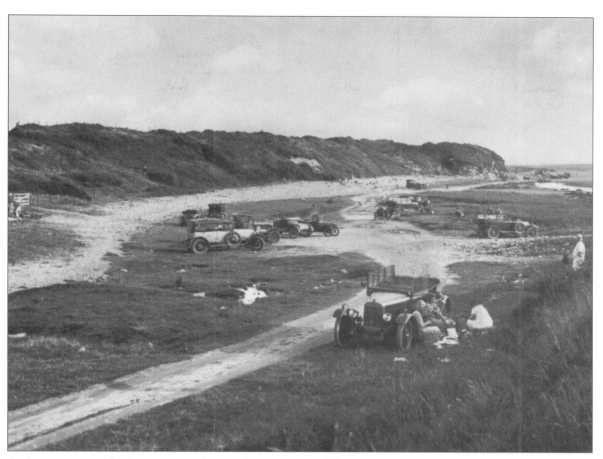

A pleasant scene of a hot summer day on the coast at Middleton, just south of Heysham, *c.* 1936. What is surprising is the sheer number of motor cars at this remote spot, although the large sandy beach was a great attraction. It was even used by small aircraft between the wars in the absence of any local airfield. Prior to the building of nearby Heysham Harbour in 1904 it was said that the most exciting event in the history of Middleton had been a dead monkey washed up on the shore here.

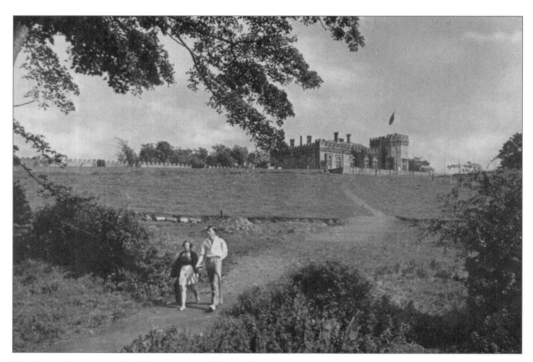

Heysham Tower was built by T.J. Knowles in about 1837 on the site of a previous house. It was set in 13 acres of well-wooded grounds including a rose garden and an orchard. The Cawthra family left during the building of Heysham Harbour and it was sold to the Midland Railway Company as a hotel, becoming the Morecambe Bay Holiday Camp in 1925 accommodating (with campers) 400 guests. The jolly group of holidaymakers below had their photograph taken outside the building at Whitsuntide 1927.

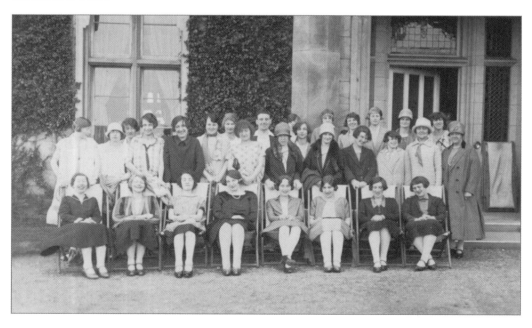

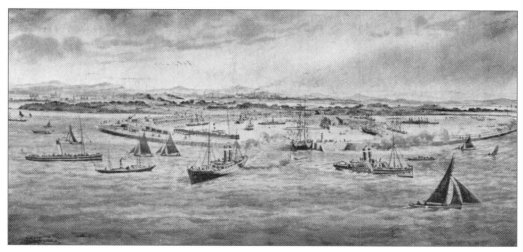

An artist's view of the proposed port of Heysham by T.H. Stephenson. It shows two basins, the one on the left which was eventually built, and another to the right which was to have a timber pond, graving dock and facilities for loading coal. The Midland Railway proposed building a new line to bring coal from the Wigan area, but this did not win parliamentary approval and the plan for a second basin was abandoned. The scene looks like a maritime equivalent of rush hour on the nearby M6, but it never quite reached these proportions!

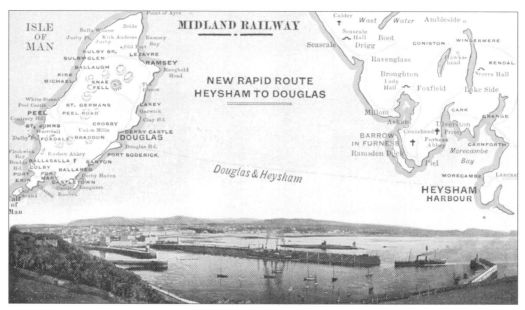

During the late nineteenth century the dynamic Midland Railway, based at Derby, expanded its services across the country and acquired by amalgamation the Belfast & Northern Counties Railway. To develop traffic and join up the various parts of its sprawling empire the company decided to build a fleet of ships and a new harbour at Heysham. This was to replace the small tidal harbour at Morecambe, the only port entirely under Midland Railway control. The new route was aggressively marketed and the company muscled in on the route to the Isle of Man as a popular holiday destination, publicised here in a rare postcard of 1904.

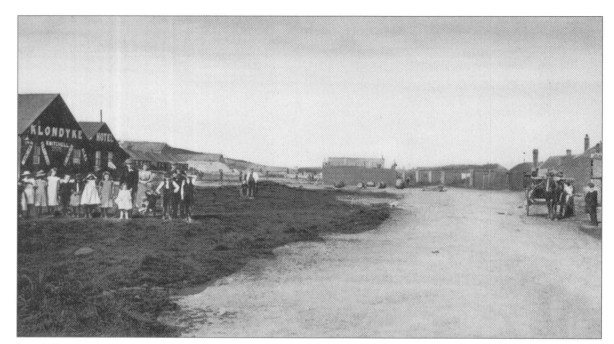

Klondyke village, Heysham, a construction camp created for the 700 resident workers building the new harbour from 1897. The men were mostly employed by the main contractor, Messrs Price & Wills of Westminster, and the firm erected a whole new temporary village of wood, corrugated iron and tarpaulin. It comprised dormitories for the single men, houses for families, a bakery, café, police station and a canteen named the Klondyke Hotel. This was the camp's 'shopping centre', with provisions supplied by Blake & Company, clothing from the Klondyke Clothing Stores (a branch of James Pilkington in St Nicholas Street, Lancaster) and meat from butchers D. Gill & Son. Next door was a barber's shop. All these buildings were taken down and sold by auction in 1904.

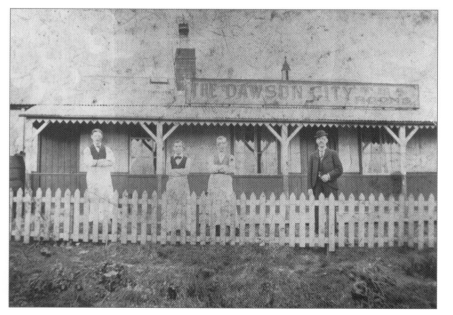

Close to Klondyke another construction camp – Dawson City – sprang up, They were both named after the famous Alaskan gold-rush towns which had equally primitive facilities and were not dissimilar in appearance. Unexpectedly, Dawson City, which was said to have 'facilities of ill-repute', boasted a tea room which appears to be far too genteel for its surroundings!

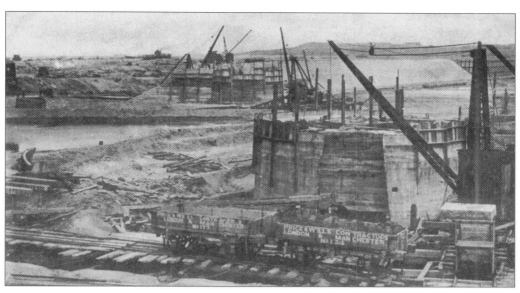

The harbour construction was a massive undertaking involving the creation of a 36-acre basin for shipping on a site covering 350 acres. At the entrance to the harbour two roundheads were built at the termination of the enveloping harbour walls. The *Railway Magazine* (November 1904) described their construction by contractors Price & Wills: 'To obtain a bedrock foundation for each of the roundheads a circular tube, or monolith, 55 feet in diameter, was formed, which sank 75 feet before it rested on a solid bottom, and this was filled in with brickwork, absorbing upwards of a million of hard bricks, and weighing, when completed, approximately 6,000 tons. [The sea] is not likely to move these masses of masonry, which will doubtless remain for many years the largest of their species.'

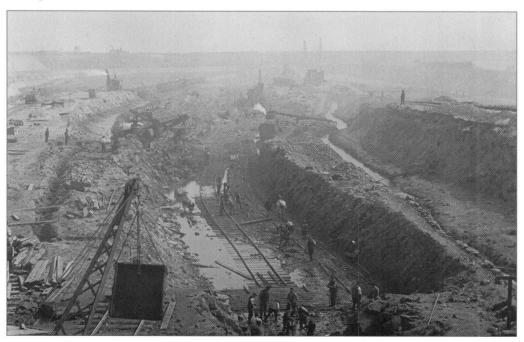

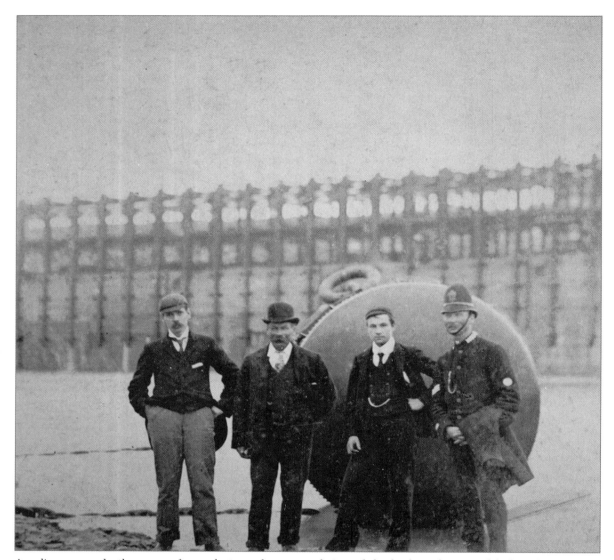

A policeman and others pose for a photograph on completion of the harbour basin and before the entrance breakwater was excavated to admit water for the first time. A police station was situated behind the Klondyke Hotel where officers were frequently required to keep order in a hard and hardened community of workmen. Fights were common, especially on Saturday night pay-day. Behind the group can be seen one of the quayside walls, rising 53 ft and allowing a minimum of 17 ft of water at low tide. The mean high tide provided a depth of 48 ft.

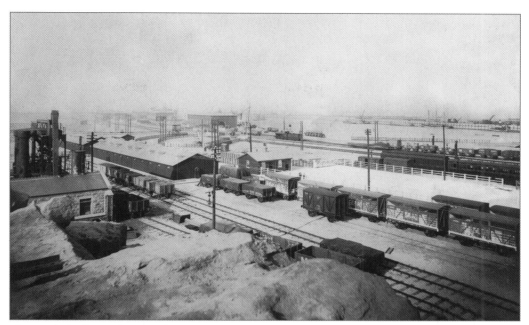

The newly built Heysham Harbour, seen on 20 September 1904 – the Midland Railway Company's magnificent new port for passenger and goods services to Ireland and the Isle of Man. The first service vessel to berth at Heysham was the company's own *Antrim* (below), on 31 May 1904, one of four ships built specifically for the new services. The harbour itself cost £3 million to build; it was a huge investment for the Midland which became the proud owner of the first port anywhere in Britain to be entirely operated by electricity. In the foreground (above) are the livestock sheds and lairages which allowed the animals to recover from their Irish Sea crossing before being sent on to market or abattoir.

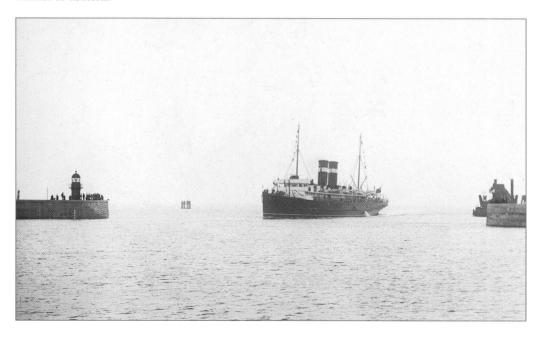

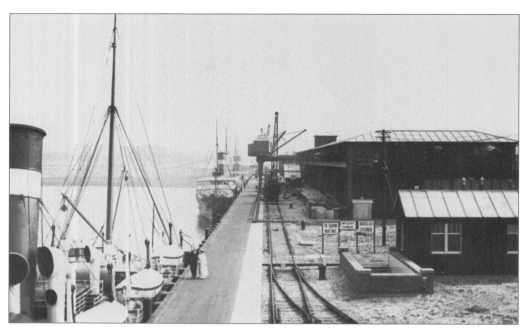

The South Quay at Heysham Harbour, the main goods, livestock and passenger quayside, probably towards the end of 1904. The two large buildings fronting the quay are the Belfast and Dublin landing sheds, where goods hoisted out of the ships by the 5 ton electric travelling cranes were loaded into railway wagons. Alongside is the trio of new Midland Railway steamers – *Antrim*, *Londonderry* and *Donegal* – built especially for the route to Ireland. The latter vessel (below, in 1905) was used as a hospital ship during the First World War. While bringing back wounded soldiers from France in April 1917 she was torpedoed by a German submarine. She sank in a very short time with the loss of twenty-nine soldiers and eleven members of her crew.

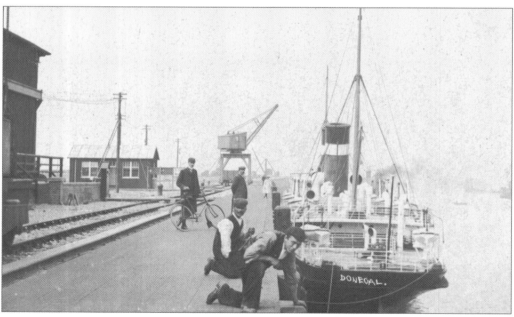

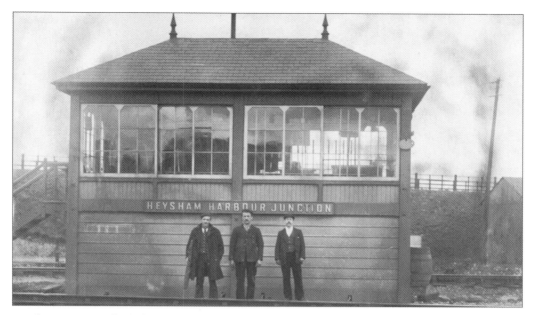

Heysham was a railway harbour and designed primarily with railway access in mind. The trains were able to load and unload goods along the quaysides and in the landing sheds on the South Quay. According to the *Railway Magazine* (1904) the masterplan was impressive, incorporating 'extensive sidings accommodation, enabling all varieties of trains to approach or leave the harbour station and sidings without having to be shunted over a network of lines that to the uninitiated makes confusion worse confounded'. The nerve centre of the railway operations was the Heysham Harbour Junction signal box at the entrance to the site, seen here some time before the First World War.

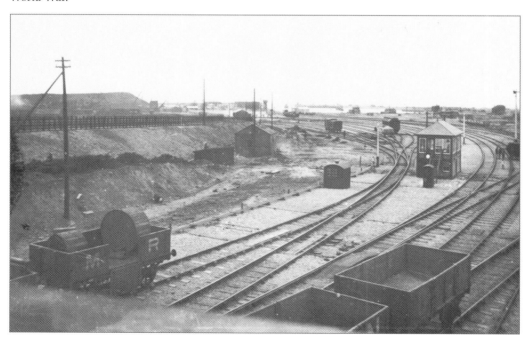

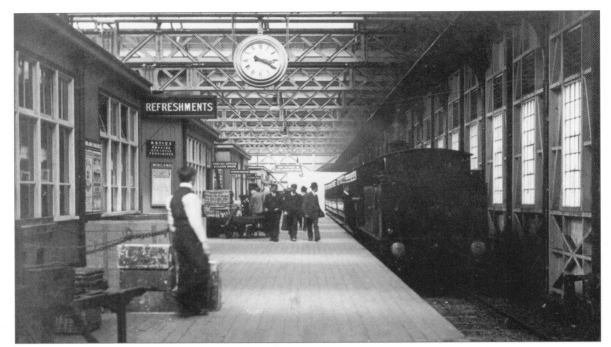

Heysham Harbour station, *c.* 1905, with a steam railcar, also called a motor train, which began providing local services between Lancaster, Morecambe and Heysham Harbour in 1904. With the growth of traffic, however, the Midland Railway decided to introduce pioneering electric trains instead, supplied with power from the new generator installed at the harbour. These new trains continued in operation on the line until 1951.

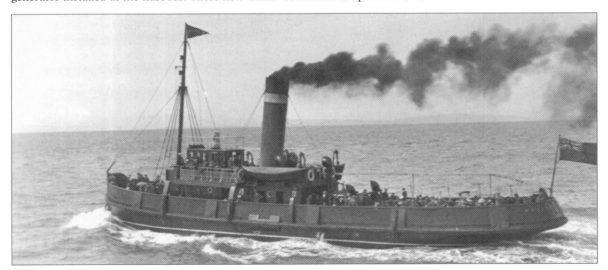

The steam tug *Wyvern*, during her remarkable 54-year service at Heysham *c.* 1920. The Midland Railway Company ordered the tug from Ferguson Brothers at Port Glasgow and she arrived in 1905 equipped with full towing apparatus and extensive passenger accommodation. This allowed her to 'poach' passengers from the services offered by the rival Isle of Man Steam Packet Company at Fleetwood, a short distance away, ferry them up to Heysham, and to take holidaymakers on excursions into Morecambe Bay and beyond, which appears to be happening here. The tug served with a local crew at Scapa Flow during the First World War and was honourably retired in 1959.

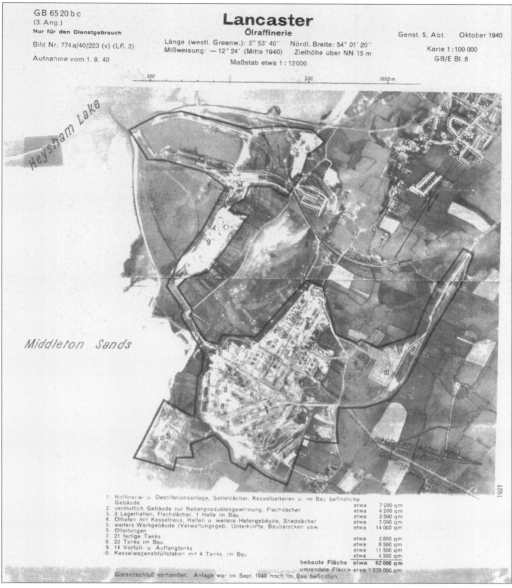

An aerial reconnaissance photograph of Heysham Harbour taken by the Luftwaffe on 1 September 1940. It highlights important targets, including the new oil installations associated with the nearby Trimpell oil refinery which was vitally important to the British war effort. Long before the war the Air Ministry saw the need to develop a refinery to supply high-performance fuel for military aircraft. Construction began on the 250-acre site at Middleton in September 1939. Heysham was at the furthest limit of German bomber range and the shallows of Morecambe Bay offered some protection from submarines to tankers discharging oil. The refinery was built by a group of companies – Trinidad Leaseholds Ltd, Imperial Chemical Industries and Shell Petroleum – whose names made up the title 'Trimpell'. Production ended in 1946, but when Shell bought the site (with ICI) in 1948 it was converted to become the company's first crude oil refinery in Britain, producing petrol, gas oils and fuel oils. It continued in use until 1983.

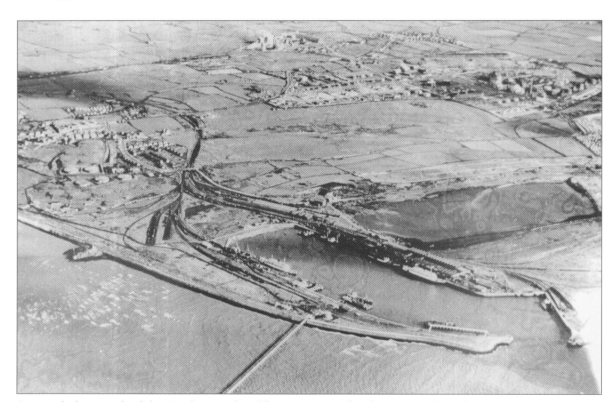

An aerial photograph of the Heysham and Middleton area. Crude oil was sent along the Ocean Oil Jetty pipeline (bottom) to the storage tanks (left) near the harbour prior to refining, and it was pumped to the Trimpell refining (top) as required. The refinery began full production in July 1941. Aviation fuel was sent out either in railway tankcars from the Middleton sidings or through another pipeline to Heysham Harbour from where it was shipped to ports around the country.

Oil tankers from the Caribbean and the east coast of America began arriving at Heysham, 2 miles from the Trimpell refinery, in 1941. They were too large to enter Heysham Harbour so the Ocean Oil Jetty (top) was built out to deep water half a mile from the harbour. Building work was delayed by the severe winter of 1939/40, which froze the seawater along the shore and created ice floes 20 ft wide and 2 ft thick. The first tanker to arrive (below), on 9 March, was the *British Confidence* seen here in her drab wartime colours secured to the buoys. She left four days later.

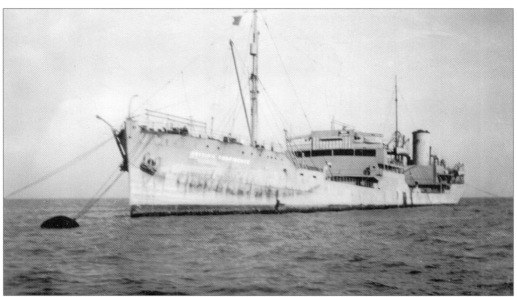

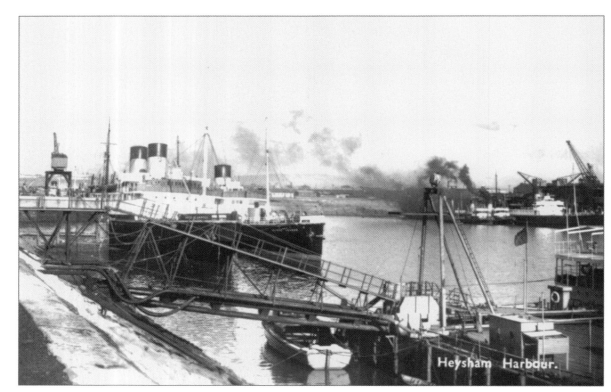

Heysham Harbour after the Second World War. The fuel refined at the Trimpell site was loaded from the North Quay on to small coastal tankers with, from 1947, the help of an oil pontoon belonging to Shell. It had been used as part of the Mulberry Harbour complex built to supply the army following the D-Day landings in June 1944. It was last used in 1976 and towed away to Barrow for reconditioning on 1 March 1977, apparently for further use in Nigeria. However, it is thought that it only got as far as Port Penrhyn in Wales.

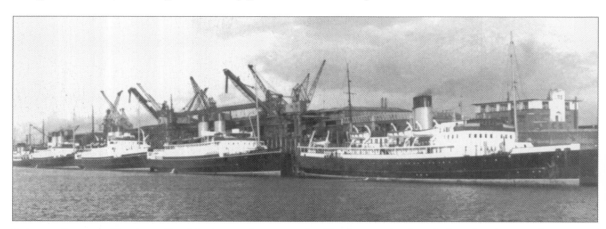

Between the wars Heysham flourished as a ferry port for Northern Ireland and the Isle of Man. This view of shipping against the South Quay on Friday 4 August 1939 is rare because of the large number of steamers in harbour at the same time. Left to right: the Isle of Man Steam Packet Company's *Snaefell* (1905) and the LMS Railway Company's *Duke of Rothesay* (1928), *Duke of York* (1935), *Duke of Lancaster* (1928) and *Princess Margaret* (1931). The photograph was taken by G.H. Fairbank of Heysham.

5

Around the Lune Estuary

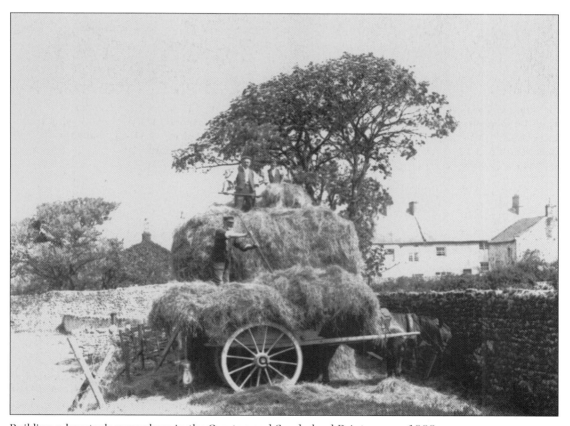

Building a haystack somewhere in the Overton and Sunderland Point area, *c.* 1900.

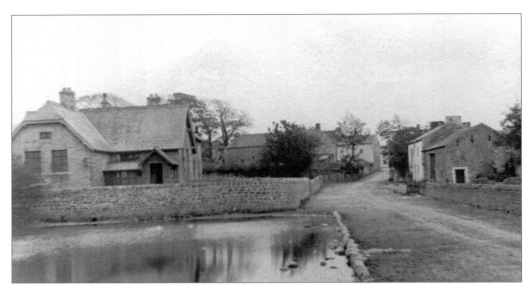

Overton school and village pond, *c.* 1900. The National School opened on 15 September 1873 and cost £700. The population of the township was around 300 and in 1880 the school enrolled between sixty and seventy children mostly from the agricultural and fishing families of the district. The school is now a private home and the pond has become a vehicle turning area and bus stop.

Architecturally, the most impressive house in Overton is considered to be the Georgian five-bayed Manor Farm House in Main Street. In its day it would have been especially prominent as an imposing and fashionable building among the poorer cottages in vernacular style. In practical terms, the extra windows would have made the house much brighter but also much harder to heat in winter.

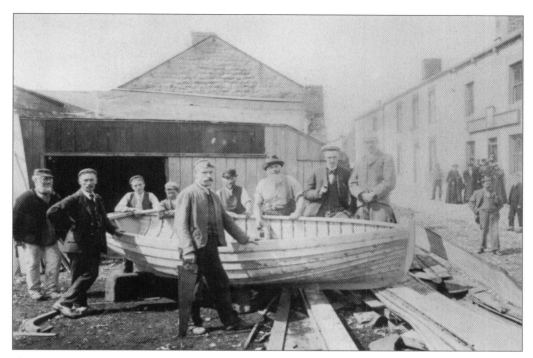

The Woodhouse family boatyard and joinery shop at Overton, possibly in the early 1900s. The firm is said to have been established in the late seventeenth century and, as with many such businesses, it made coffins and a wide variety of wooden products for local use. The firm made a number of smaller rowing boats in addition to mussel and whammel (salmon-netting) boats, trawlers and yachts for local buyers. The yard ceased building new vessels around the time of the Second World War but continued with small boat repairs into the 1970s.

A view of the Main Street, Overton, from near the Globe Inn (now the Globe Hotel), *c.* 1900. According to the Victoria County History, 'Overton has an old-world air and consists largely of stone-built whitewashed cottages of eighteenth-century date, but some of the houses are older'. Although fewer are now whitewashed, many have retained their carved doorheads and low mullioned windows that date them to the late seventeenth century.

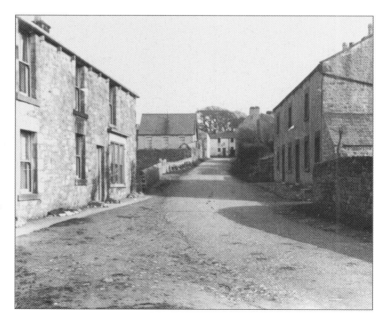

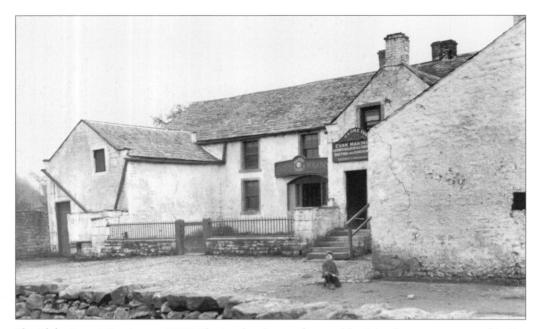

The Globe Inn at Overton, *c*. 1900. The inn has been a favoured hostelry for many years and in the late nineteenth century had an extensive pleasure garden which attracted many holidaymakers by charabanc from Morecambe and elsewhere. The sign above the door records Evan Makinson as the licensee.

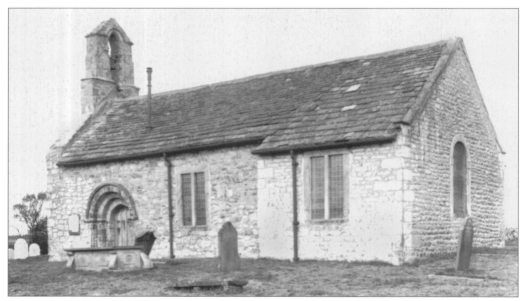

St Helen's is a delightful gem of a church overlooking the Lune estuary at Overton. In early times it was close to the Lune ferry crossing from Glasson by which some parishioners attended services. The church is an ancient foundation and was built by 1140, as the Norman south doorway (left) indicates. It is now crowded by mature trees and much gloomier than after the restoration of 1902, as seen here.

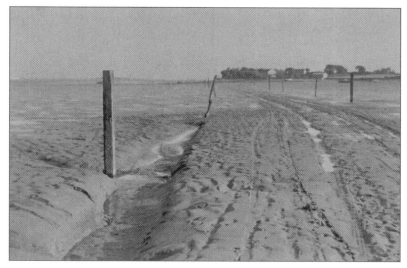

Low tide on the road between Overton and Sunderland Point in the interwar period. During the course of the twentieth century the mud flats have been colonised by salt-marsh plants and its appearance has completely changed. The tidal road is now marked with concrete pillars which were used originally as road blocks during the Second World War.

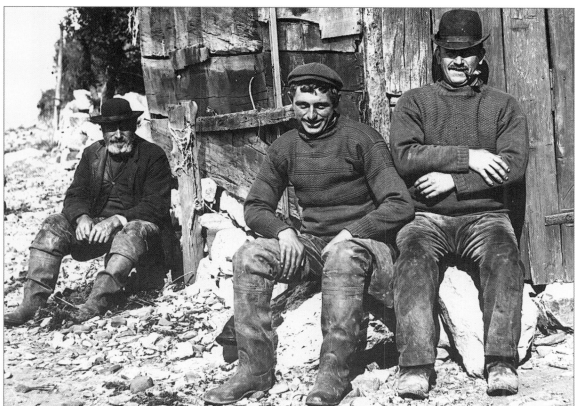

Three unidentified fishermen sitting outside their hut at Bazil Point, Overton, beside the River Lune, c. 1900. The Lune estuary was a rich source of seafood, including salmon and sea trout, flukes (flounder), mussels and shrimps. It provided year-round employment for many fishermen from Overton and Sunderland Point and the huts which dotted the shoreline stored much of their equipment. These fishermen are dressed in typical fashion, variously sporting ganseys (Guernsey sweaters), corduroy trousers, rubber boots (waders) and clogs.

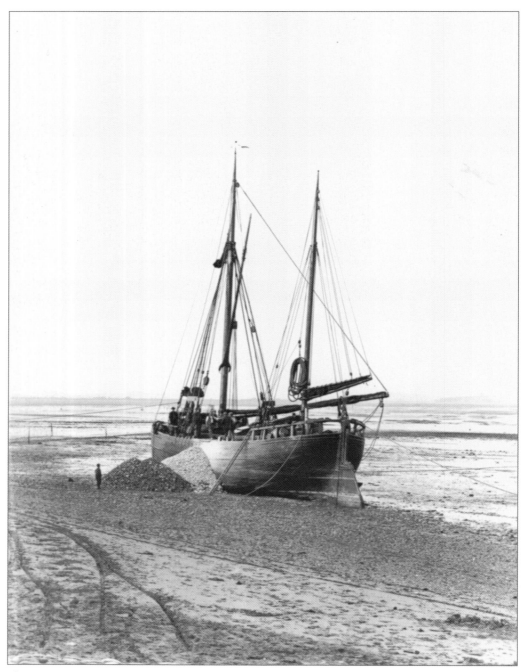

The 70-ton Mersey flat *John & William* unloading a cargo of roadstone on the foreshore at Sunderland Point in the late 1890s. Vessels of this type were a common sight on the north-west coast and carried a variety of bulk cargoes. They were heavily built to withstand the rigours of continual grounding where no suitable harbour existed. The vessel was owned at Llandulas in north Wales, a last bastion of sailing vessel ownership well into the early twentieth century before steam vessels and motor lorries made them uneconomic.

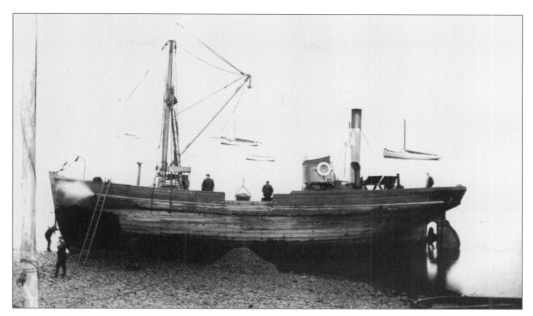

A wooden-hulled coaster fitted with a steam engine on the foreshore at Sunderland Point, *c.* 1900. The advantage of steam was that it could also be used to power the derrick crane which appears to be lowering bucketfuls of roadstone over the side. In front of the funnel is an open bridge, topped by protective canvas, where the crew steered and navigated the vessel in all weathers.

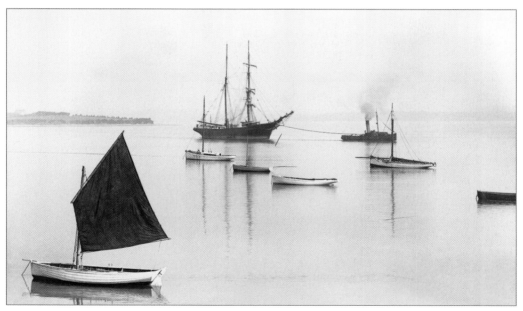

The view of the River Lune between Bazil Point and Fishnet Point, at Glasson, from the First Terrace at Sunderland Point, *c.* 1900. Sailing vessels were frequently towed to and from Glasson Dock by the Lancaster Port Commission's tug *John O'Gaunt* (1894), although other tugs occasionally obliged. The vessel being towed is a barque, probably a Norwegian vessel engaged in the timber trade to Glasson, which was prospering at this time.

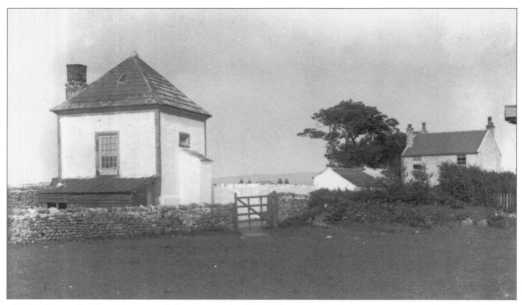

The building (left) at the top of the Lane, Sunderland Point, is thought to have been built in about 1710 as a lookout for merchants and pilots waiting for their ships to arrive in the Lune. To track the changes in wind direction, which was all-important in the days of sail, a compass rose was painted on the ceiling inside with an arrow connected to a weather vane on the roof. It was built on top of a low hill and had two large windows which made it an excellent vantage point. Later in the century it was converted into a small cottage known as Summer House. This photograph was taken in about 1897 before its present Victorian extension was added.

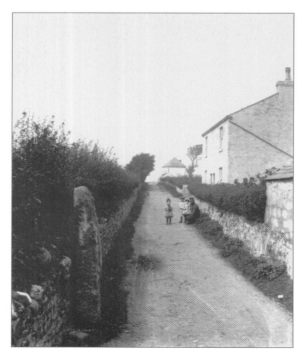

The Lane at Sunderland Point leads to the western side of the peninsula and Sambo's Grave, belonging to the first recorded black African to arrive in the district. He appears to have been a servant or cabin boy to the master of a ship arriving from the West Indies in 1736, and died soon after his arrival in the brewhouse behind the Ship Inn, now Upsteps Cottage (just off the photograph to the right). The semi-detached Hawthorn Cottages in this view were built by the Lune pilot Tom Spencer on land sold by his father, James 'Rising Sun' Spencer, in 1889.

The Walker family were long-standing residents of Sunderland Point. Christopher and his son John were both harbour masters at Glasson for the Lancaster Port Commission. Here John's wife and their two daughters Fanny and Jinny, with an unidentified relative, are enjoying the fresh air outside their house, 10 First Terrace, in about 1905. A son, also John, was a keen amateur photographer and was responsible for this photograph and many others reproduced in this volume.

The First Terrace at Sunderland Point, *c.* 1900. The figures on the left are wildfowlers with their gun punt, the birds no doubt providing a welcome supplement to this diet. The eighteenth-century post, surmounted by a ball and finial, and the smaller stone pillars, were relocated here from beyond the Wynt, the narrow lane leading off the First Terrace on the right of the picture. They marked the main route to the Summer House. The building with the large bay window at the end of the Terrace was formerly the Ship Inn.

The Second Terrace, Sunderland Point, with the village's famous 'cotton tree' – actually a rare female black poplar whose white blossom resembled cotton wool. It was old when this photograph was taken in about 1900 and it survived until brought down by gales on New Year's Day 1998. On the left is Cotton Tree Cottage, with a stone above the door inscribed with the initials of its builders, Thomas and Mary Weeton, 1751. Thomas was a talented and experienced master of ships trading to the West Indies, and died aboard his privateer in an action with an American vessel in 1782.

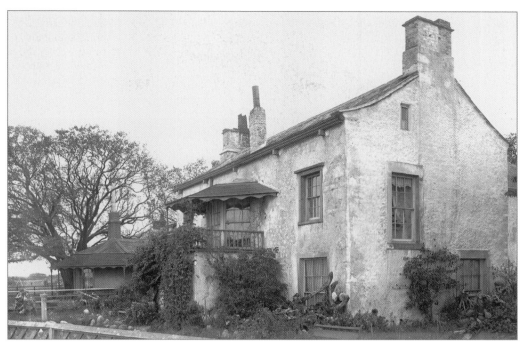

The Hall at Sunderland Point dates from 1683 and was built by Robert and Elizabeth Pearson. These images date from *c.* 1900. It remains a most attractive house with stylistic parallels to plantation houses. Interestingly, the house was later occupied by Robert Lawson (1690–1773) of Sunderland Point, an important merchant in West Indies trade who went bankrupt in 1728. The covered veranda and balcony are certainly practical, giving shelter from rain as well as sun. The semi-circular low roof to the left of the main building identifies Hall End, now a separate house but originally built as an annexe. In 1872 the Hall was advertised for sale or rent in the *Lancaster Gazette*, and boasted a first-floor drawing room, four main bedrooms, three attic bedrooms for the servants, and a stable and coach house (left, below) adjoining the lime-washed cottage occupied at that time by William Townley.

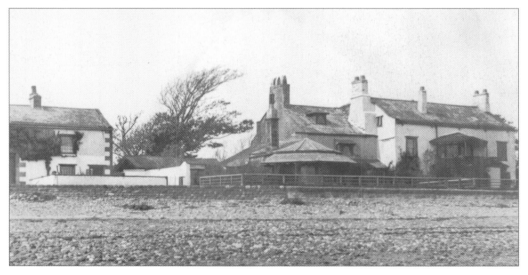

Dolphin House was built in 1912 by the talented Scottish painter Philip Gilchrist, who owned much of the land and village of Sunderland Point. It had formerly been an open field separating the First and Second Terraces and on which the village fêtes were held. It was bounded by a shelving beach beside the river where boats had traditionally been drawn up.

The Mission Church at the top of the Lane at Sunderland Point was built in 1894 at a cost of £250 and was designed by celebrated Lancaster architects Paley & Austin. The little church was subsidiary to the main parish church at Overton. Services were taken by the Vicar of Overton every fortnight and it is seen here decorated for Harvest Festival some time around 1900.

 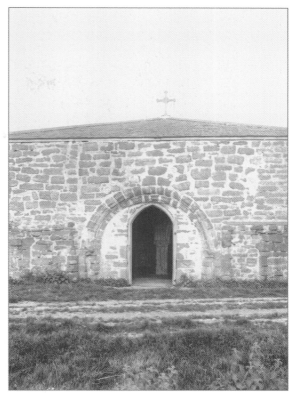

Exterior and interior views of the well-preserved thirteenth-century chapter house of Cockersand Abbey on the Lune estuary. It is all that remains of the extensive monastic complex built by Premonstratensian canons from Croxton Abbey, Leicestershire. They were given this remote and exposed stretch of coastline by William of Lancaster, 2nd Baron Kendal and Lord of Wyresdale, in 1184 and decided to establish a small hospital on the site formerly occupied by the hermit, Hugh Garth. The abbey received large gifts of land during the thirteenth century and became the third richest monastery in Lancashire after Furness and Whalley. It was badly damaged in the Scottish raid of 1316 and coastal erosion also came to undermine the buildings. The abbey was eventually suppressed on 29 January 1539 forcing the removal of Abbot Poulton and twenty-two canons. The Crown sold the land to John Kitchen of Hatfield for £700 in 1543, and his daughter Ann married Robert Dalton of nearby Thurnham Hall. The Dalton family used the chapter house as a burial vault from the mid-eighteenth century until 1861.

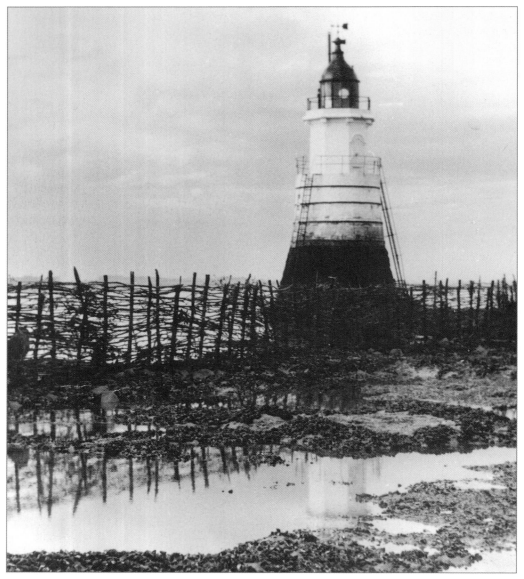

Plover Scar lighthouse at Cockersands was built by Lancaster Port Commission in 1847 together with the wooden lighthouse on the shore half a mile away. They were designed by John B. Hartley, son of the famous Liverpool dock engineer Jesse Hartley, and aligned in such a way as to help shipping entering the Lune estuary. The Plover Scar light is 50 ft high and located next to the ancient fish baulk (opposite). It is still reached by means of a causeway and an iron ladder up to the balcony and lamp room. Paraffin oil originally fuelled the lights and it had to be carried out to the lighthouse twice a day to replenish the supply. The journey had to be made across the foreshore at all times of the day in biting winds and in all weathers. The lighting mechanism was changed to acetylene gas in 1951. The first lighthouse keeper was Francis (Frank) Raby, from 1847, followed by Henry Raby in the 1870s, Richard (Dick) Raby, helped by his sister Janet, until 1945, and the Parkinson family from 1946 until 1963. The iron straps which encircle the tower were added later following the appearance of worrying cracks in the stonework.

The fish baulk was a permanent structure built on the foreshore to trap salmon and many other fish on the ebb tide. As the water fell the fish were left in shallow pools without any means of escape. The baulk was an ancient foundation and was probably used by the monks of nearby Cockersand Abbey in medieval times. The walls, or hedges, were traditionally built using posts of oak interwoven with branches of hazel. The baulk remained in use until the 1960s.

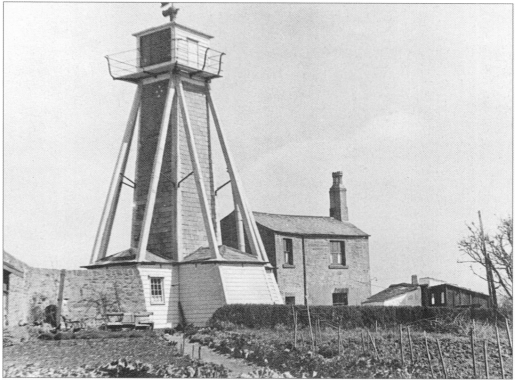

The Upper Light, next to the keeper's cottage, was built of wood for economy and stood 54 ft high. It was buttressed with eight posts, which was a wise precaution on this exposed shore. The Plover Scar light, built of stone on the foreshore, cost £1,020 and the Upper Light only £650. They were built by the contractor Charles Blades of Lancaster. The light was demolished in 1954, replaced by a functional but ugly steel tower with automatic electric lights. Thankfully, this too has now gone.

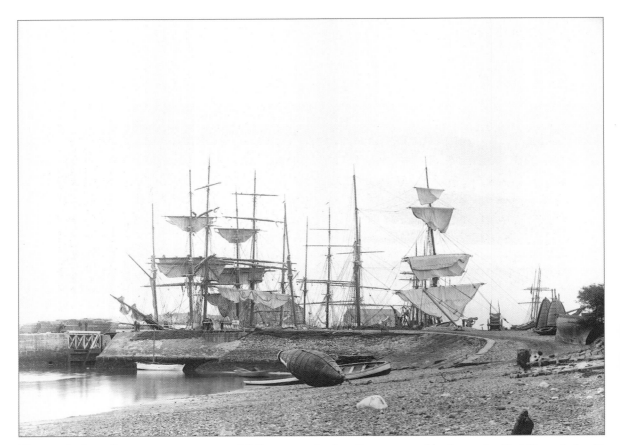

The wet dock at Glasson covers an area of 2.7 acres, and when it was opened by Lancaster Port Commission in 1787 it was advertised as being able to accommodate '25 large merchantmen . . . [up to] . . . 200 tons burthen'. It would have been a tight squeeze. Ships traded as far as the West Indies and the Baltic and Glasson continued to be well used throughout the nineteenth century even though trade gradually declined. Here the dock is shown during the swan-song of the sailing ship at the end of the nineteenth century, with a number of vessels drying their sails. The Port Commission's channel buoys are beached for repair and maintenance, and a pile of imported timber on the riverside quay (left) is waiting to be moved inland by rail.

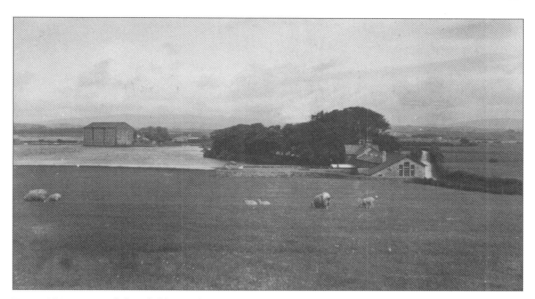

From 1833 most of the children of Glasson Dock, Old Glasson and the surrounding farms were educated at the new school built in the south-west corner of the canal basin. The site was donated by the Lancaster Canal Company and built with money raised by the Vicar of Lancaster, Revd John Manby. Originally, the school comprised a single classroom 21 ft by 18 ft and cost just £174. It is still in use today but greatly enlarged. The tall building to the left is the old Lancaster Canal warehouse built beside the canal basin in 1826. Sadly, it was demolished in about 1940.

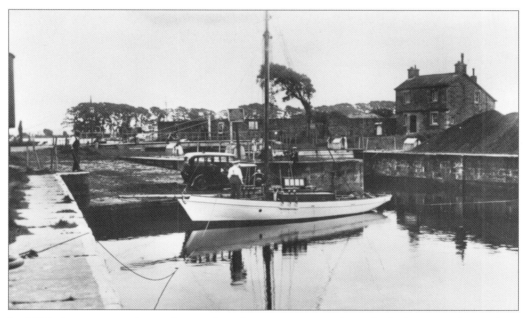

In 1826 the port was given a boost when the Lancaster Canal was built down to Glasson from Galgate. A large canal basin (left) was connected to the existing wet dock by an intervening lock, seen here beyond this smart-looking yacht, c. 1930. To travel from one side of the dock to the other, road traffic had to use this swing bridge which is still a feature of Glasson today.

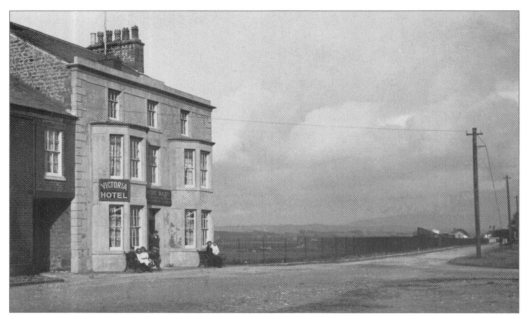

The Victoria Hotel at Glasson, proclaiming Robert Raby the licensee and retailer of 'ale, porter, spiritous liquors and tobacco'. The hotel opened shortly after 1837, the year Queen Victoria acceded to the throne, and by 1878 it was in the hands of famous Lancaster brewer and innkeeper William Mitchell. This photograph was taken in the early 1900s, when the trade of Glasson had become a lot quieter but tourist excursions had grown in popularity.

Four generations of the Robinson family at the railway station, Glasson Dock, before the First World War. On the right is Stationmaster Michael Robinson (1854–1921), whose cap bears the initials of the London & North Western Railway Company which opened the line on 9 July 1883. The railway helped supply James Williamson's great Luneside linoleum factory with raw materials, particularly china clay and linseed oil, which arrived by sea at Glasson. Although passenger services ended in 1930 the line continued in use for freight until September 1964. On the left is Michael's son Ernest and grandson Cyril, sitting happily on the knee of his great-grandfather Robert.

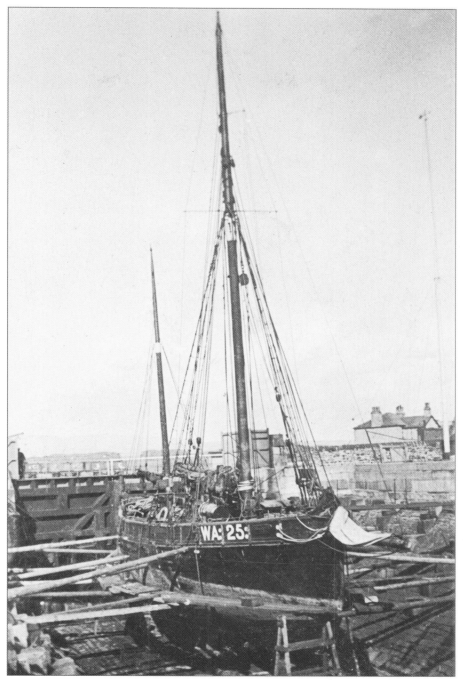

The Whitehaven auxiliary trawler *Reliance* in the graving dock, probably for mainten-ance purposes, on 17 June 1931. A staging has been erected around the boat to allow the hull to be scraped and repainted. Behind are the gates sealing the dry dock from the main basin. Many fishing trawlers came to Glasson for this purpose, especially from Fleetwood, and some were even built at Glasson.

Shipbuilding was a long-standing industry at Glasson established by James Penny Nicholson and Matthew Simpson as early as 1837. The last sizeable vessel was launched in 1907. By far the best known of the fifty vessels built at the yard was the schooner *Ryelands* (1887), not only for the fact that she was the last to survive but also because of her distinguished film career. In 1949 she was sold to RKO/Walt Disney Productions and renamed *Hispaniola* for the film *Treasure Island*, then sold to Scarborough Corporation as a tourist attraction. In 1954 Elstree Pictures Ltd acquired her for use as *Pequod* in the film *Moby Dick*. The following year she was used by Sapphire Films Ltd and renamed *Moulin* and *Dilipa* for the television series *The Buccaneers*. As the *Moby Dick* (seen here at Glasson) she sailed to Morecambe to become a tourist attraction once more, but sadly (or thankfully, considering her greatly altered appearance) was destroyed by fire in 1970 and broken up.

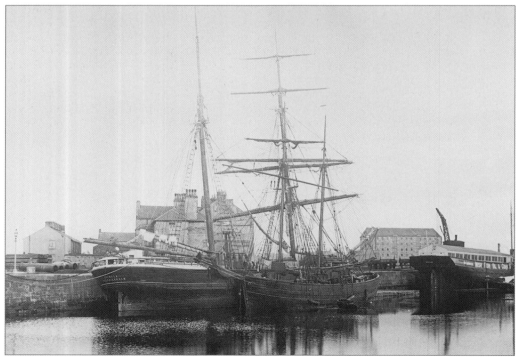

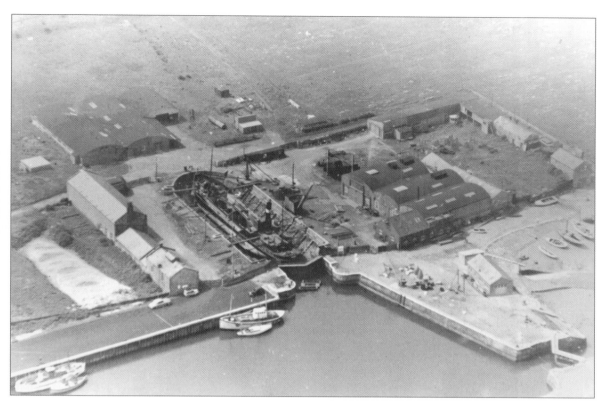

Glasson Dock was originally developed as a riverside pier port for shipping unwilling or unable to reach Lancaster, 6 miles further up the River Lune. The pier, part of which can be seen bottom right, was built by Lancaster Port Commission in 1782 and was developed into the wet dock, or basin, shown here, which was opened in 1787. Top right is an enclosed area where, from 1837, ships were built and launched into the river at high tide. The shipbuilders also operated the Port Commission's graving dock (centre) where ships were repaired and maintained from 1840. Various sheds round about were used for ship fabrication, the making of sails and other fittings required by the vessels. To the left is the abandoned excavation of a 500-ft long, 45-ft wide haulage slip begun by Nicholson & Sons' shipyard after the First World War. In front is the West Quay, built in 1958 and financed by the Ministry of Transport at the behest of the Admiralty. It was thought that the new quay would assist the adjoining shipyard with the repair and maintenance of naval vessels in wartime.

Opposite: A scene typical of Glasson Dock at the end of the nineteenth century. Sailing vessels were still much in evidence but were slowly being put out of business by the growing number of steamships. The schooner lying against the East Quay is the *Primula*, a Norwegian vessel registered at Frederikshald and built in Nova Scotia, Canada, in 1865. She probably brought the cargo of timber lying on the quayside. In front is an unknown hulk advertising Irish fish oil.

The 110-ft long Fleetwood motor yacht *Dorade II* in the dry dock at Glasson in 1938, resting on wooden graving blocks and shored up along both sides. The 190-ft long dry dock was of great importance to the Lancaster Port Commission that had it built in 1840 to the design of Jesse Hartley. It attracted large numbers of ships that would otherwise have gone to Liverpool, Belfast or the Clyde for repair and maintenance. The first ship to enter the dock was the brig *Lancaster* on 23 December 1840 followed by a further seventy-nine vessels during 1841. Alas, the number of ships dwindled during the next century and in 1968 the shipyard tenants, I. Jackson (Welding Engineers) Ltd, ceased trading. The following year the dry dock began to be filled in and it remains preserved under tons of rubbish, perhaps to be excavated at some future date.

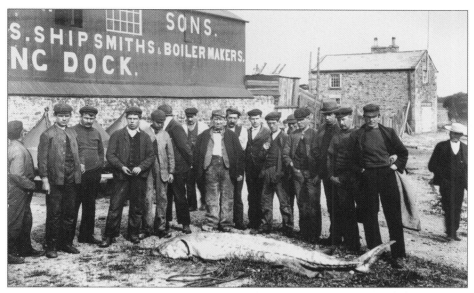

Glasson Dock was home to a few seafarers, but most of the working population, perhaps as many as seventy in 1881, were employed in the shipyard. Some of them, in their wooden clogs and working clothes, can be seen in this photograph alongside the fishermen responsible for catching this rare sturgeon in the Lune estuary in about 1896. Beyond is the Glasson Custom House of 1835, which became redundant when the last customs officers left in 1924. Ships were launched from the building slip alongside.

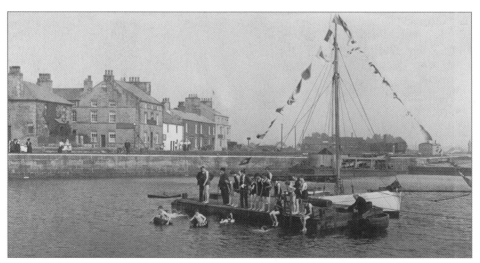

The dock at Glasson was sometimes used for leisure as well as business. Before the First World War regattas were popular everywhere along the coast, and in July 1914 Glasson folk took part in swimming, rowing and, in this photograph, barrel races from a pontoon. On the East Quay (left) is the Caribou Hotel, a fine building adjoining some white cottages. This was possibly the first building at Glasson and was originally known as Mr Salisbury's House, referring to the wealthy Lancaster West Indies merchant who built it in the late 1700s. It was used as both a dwelling and warehouse, and in 1781 it was listed as an alehouse as well.

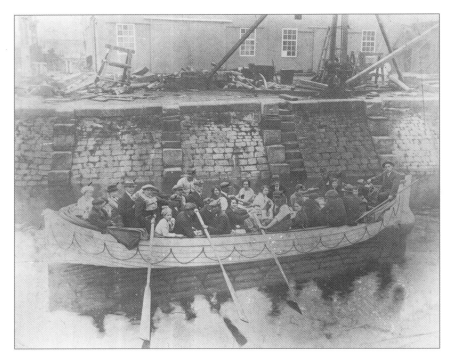

After the decline of ship repair business following the First World War the shipyard at Glasson had difficulty finding enough work. Some unusual projects were pursued, including building surf boats for use in West African waters by Elder Dempster, the Liverpool shipping company; and the prototype of Ivan Fleming's patent lifeboat, seen here being tested in the dry dock at Glasson in 1921. Unfortunately, production of the lifeboat was undertaken elsewhere.

6

The District at War

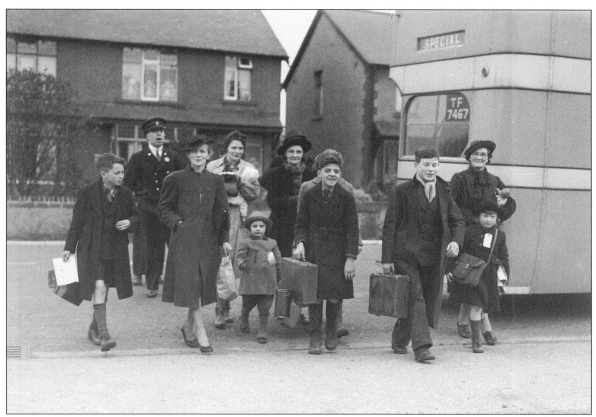

Evacuees from London on their way to new homes in Morecambe, *c.* 1940. On 23 October 1940 some 424 children and 232 mothers and attendants arrived at the station. They were escaping the London Blitz. Double-decker buses took them around the area, off their normal routes, to deliver them to their new homes. Notice the labels worn by the evacuees. By September 1941 most had returned home.

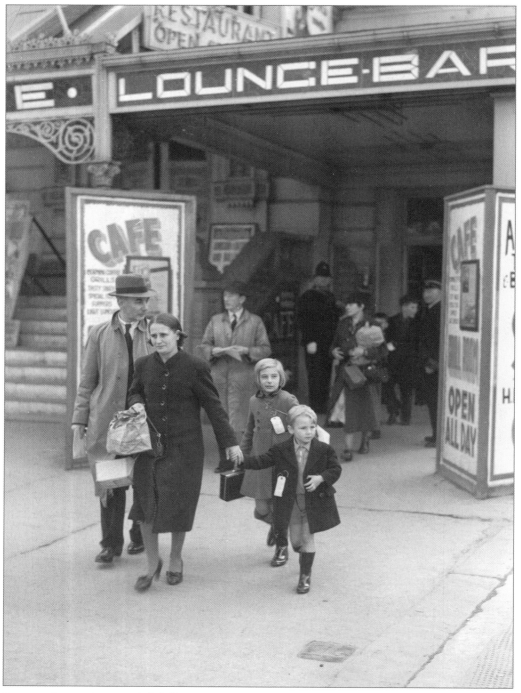

Evacuees leaving Morecambe's billeting station, the Winter Gardens, with their foster family, *c.* 1940. Fearing air raid attacks on the country the government's evacuation scheme was organised even before war broke out. This district received many evacuees – children and working adults alike – over the years of the conflict. Lancaster alone estimated that it billeted 50,000 people.

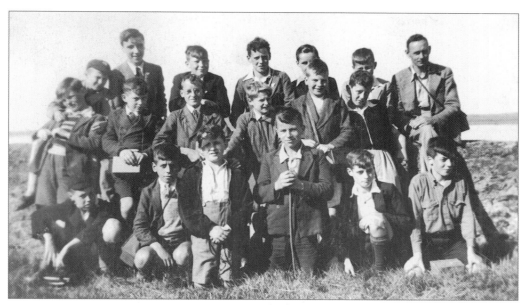

Boys from Seedley Council School in Salford on a nature ramble from Greaves, 1939. Schools were twinned in the evacuation scheme sending teachers with their pupils. With the large influx of children to the area local schools ran a double shift system – half the day in the classroom and the other half on nature walks or sports. As children drifted home so alternative arrangements were made. Notice the children's gas masks.

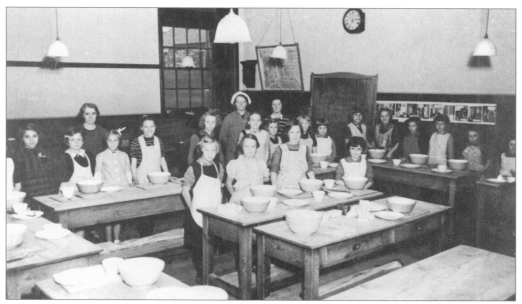

Girls from Seedley Council School in Salford during a cookery class, December 1939. Seedley School was twinned with Greaves, but for this class the girls attended the Storey Institute. For these domestic science sessions cookery was alternated with laundry classes. On the front row, left to right: June Temple, Myra Parkinson, Dorothy Ashmead and Olive Hill. As the war continued some evacuees moved from Greaves School to St Paul's Parish Hall across the road.

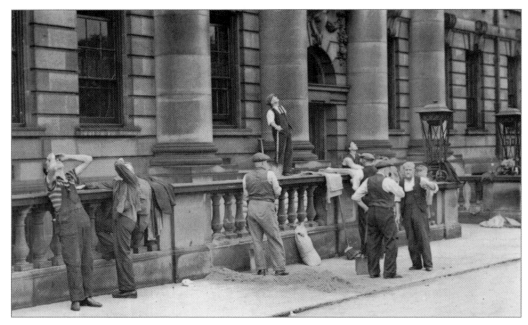

Workmen filling sandbags to protect Lancaster Town Hall, September 1939. The basement of the town hall housed the ARP control room for Lancaster and was strengthened and sandbagged in readiness for the effects of aerial bombing. Individuals were called upon to protect their own homes too. As early as 1938 every home was sent a booklet with advice on blackout, first aid and fire fighting equipment and the creation of a refuge room in the event of air raids.

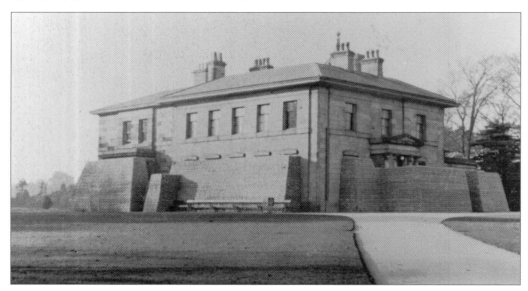

Ryelands House, Skerton, with sandbag protection, c. 1939. This had been the Lancaster home of the local industrialist James Williamson until his death in 1930. It was bought by the corporation for community use. In the war it housed an emergency ARP control room in case Skerton Bridge was bombed and communications across the River Lune were severed. Its grounds and outbuildings also housed a gas decontamination centre and fire crew from the Auxiliary Fire Service (AFS).

Assembling gas masks in the basement of Lancaster Town Hall, February 1940. Gas was used in the trenches during the First World War to devastating effect. Despite Germany signing up to the banning of gas in warfare (the Geneva Gas Protocol) the government still felt it prudent to protect the public. Gas masks were in production as early as 1937. Some 45,000 were assembled at this town hall ready for distribution. In March 1938 Morecambe announced that it had a surplus of 2,000 large gas masks but a shortage of medium and small ones!

ARP warden on a gas exercise on King Street at the corner with Market Street, *c.* 1940. The threat of gas attacks was taken very seriously. Wardens were trained in gas identification and were responsible for warning the public in their sector of an attack. There were even gas detector panels fitted to posts, road signs and letterboxes at fifty-two locations around Lancaster. Everyone was supposed to carry their gas masks at all times. Fortunately, gas was not used in the Second World War.

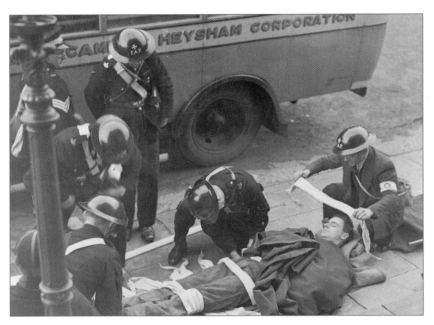

An ARP exercise in Morecambe's West End, October 1939. Vast numbers of people were needed to implement the local ARP plans. Wardens, fire fighters and fire guards, observer crews, first aid staff, gas identification and decontamination squads, rescue parties and demolition crews, police, control centre staff and messengers, support services running rest centres, enquiry centres and canteens were all essential to the scheme. Recruitment began in Lancaster in January 1938. By March 1939 Morecambe had 450 trained wardens on their books.

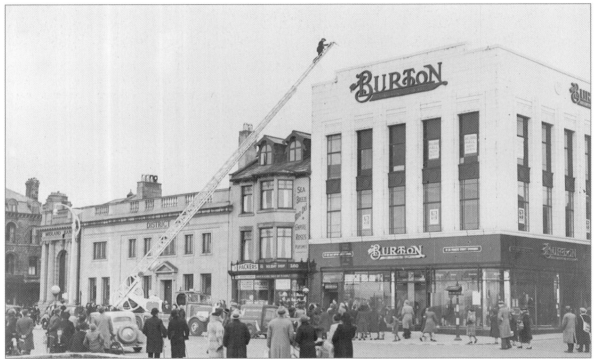

A full scale ARP exercise in progress on Morecambe front, October 1939. Training was essential and local police started their civil defence programmes as early as 1936. Alongside continuous training, exercises tested the crews to see how successfully they worked in the field. Some were more successfully than others. In July 1939 another Morecambe exercise showed how few residents were heeding instructions to black out their homes effectively. This would become a finable offence.

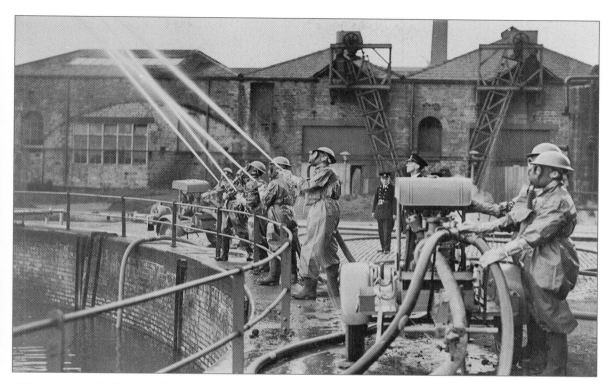

AFS training on St George's Quay, 1939. The crews are wearing full anti-gas suits. The AFS was recruited to help the local fire brigade. Volunteers started joining as early as March 1938. By February 1939 Lancaster still needed seventy volunteers to reach their target. Morecambe had fared much better with 168 men and women on their books. In December 1940 Lancaster staff went to Manchester to help fight the many fires raging during the Blitz. In 1941 the National Fire Service was formed.

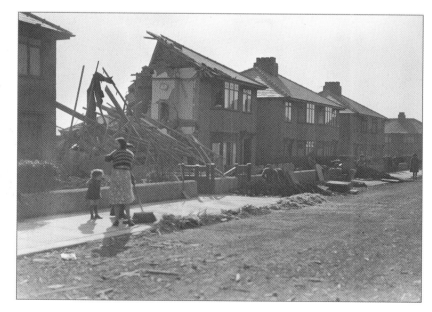

Bomb damage in Douglas Drive, Heysham, after the air raid on 13 March 1941. The district was fortunate in escaping mass bombing raids. This picture shows the aftermath of the area's worst attack. Fourteen bombs fell in the Douglas Park area, particularly on Laureston Avenue, Douglas Drive and Tomlinson Road. As well as extensive damage to property the raid left two elderly residents dead and several injured. One gentleman had to have his leg amputated.

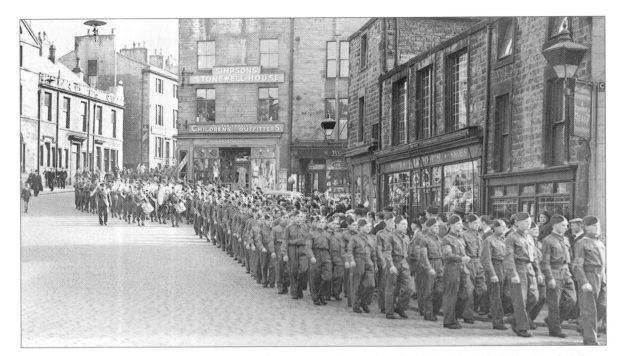

The Home Guard marching through Stonewell, Lancaster, September 1940. In May 1940 the Local Defence Volunteers (LDV) were established amid fears of invasion after British troops had been forced out of Europe. LDV units were established across the district. Their members were aged seventeen to sixty-five, and were too young, too old or exempt from the forces for whatever reason, including reserved occupations. During the summer they became the Home Guard. Duties included guarding strategic sites – especially river and canal crossings, major roads and railway lines – and being ready for combat should invasion occur.

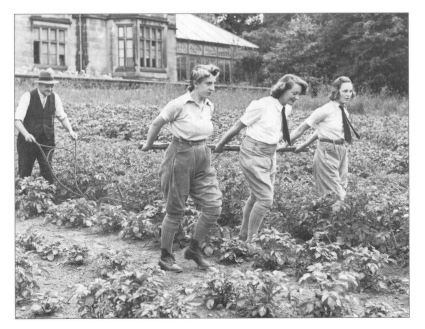

Members of the Women's Land Army cultivating the gardens of Greaves House with Joseph Stirzaker, corporation gardener, at the helm, c. 1940. This organisation was not new – it started in the First World War. Women worked on every aspect of farming and food cultivation including driving and repairing farm machinery – some even joined the Timber Corps. The government encouraged people to grow their own food in a bid for self-sufficiency. Areas of parkland – like Williamson Park – were given over to food production.

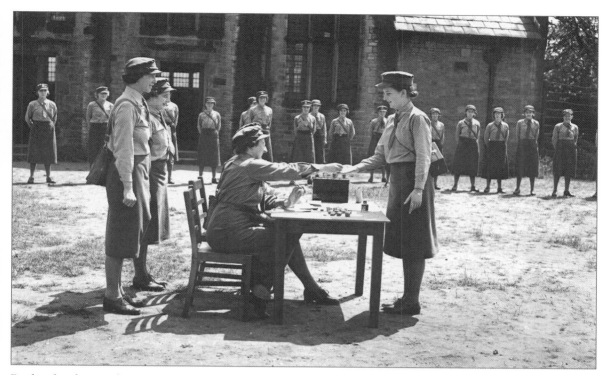

Payday for the Auxiliary Territorial Service (ATS) at Ripley Hospital, *c.* 1940. Along with the Women's Royal Naval Service (WRNS) and Women's Auxiliary Air Force (WAAF) the ATS was affiliated to the forces, and was one of several options open to women who faced conscription from December 1941 onwards. While Ripley Hospital was the ATS reception, Bowerham Barracks was their headquarters and main training centre.

ATS mechanics working at Quernmore Park, July 1943. When this photograph was seen in the local paper it was captioned 'ATS girls doing "men's work".' The ATS was a non-combatant force with some 116 categories of employment open to its staff; from fitters to wireless operators, clerks to radar operators and cooks to drivers. Even so some sixty-seven women were killed in action, nine died of wounds, 313 were wounded and a further sixteen were posted missing. Notice that the jeeps are left-hand drive and were presumably American.

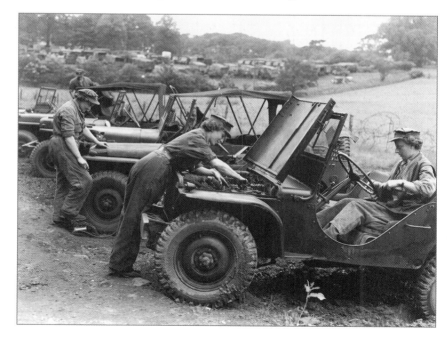

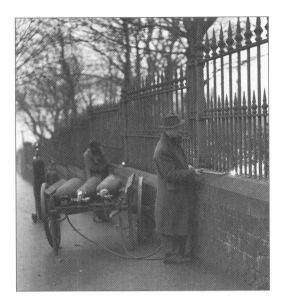

Cutting down iron railings at Williamson Park, October 1942. There were so many salvage campaigns – paper, pans, food slops and even railings. In June 1941 the corporation agreed to the removal of railings and gates from public sites such as the castle moat, Williamson Park, Scotforth and Skerton Cemeteries. The public was supposed to follow suit. Some ironwork survived for safety reasons – balconies, steep steps, but most walls show signs of this campaign. It is not clear that these railings were ever recycled.

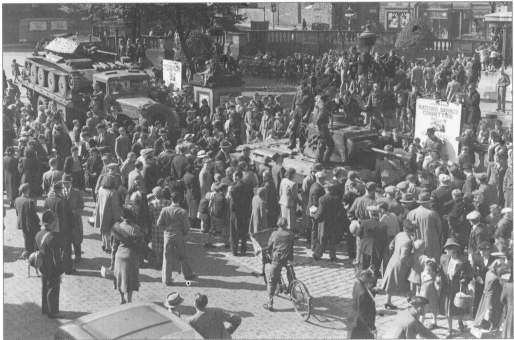

Tanks in Dalton Square, part of the 'Save for Tanks' campaign, August 1941. The cost of war was spiralling – in early 1940 it was £4 million a day, but two years later it had leapt to £15 million a day. Even with 50 per cent income tax more funds were needed. National Savings took many forms – local collecting clubs, war bonds and War Weapons Weeks. Staggering amounts of money were raised. In 1941 this tank campaign raised enough for eight tanks each costing around £15,000. In May 1943 a Lancaster Bomber displayed close to the Royal Lancaster Infirmary, in Wings for Victory Week, helped raise £677,515 for the war effort.

Victory in Europe (VE) party in Dunkeld Street, Lancaster. VE Day was designated as 8 May 1945. Celebrations like this were widespread across the district. Somehow enough food was found to throw street parties and many of the children received small gifts too. Notice the brick-built public shelters to the right of the photograph. There were church services across the district, a children's procession and a communal singing event in Dalton Square.

The Victory in Japan (VJ) parade in Ashton Drive, August 1945. Many local families did not feel the war was over when victory was declared in Europe. For those with family and friends in the Far East the war did not end until VJ Day, on 15 August 1945, even though the formal surrender did not take place until 2 September. But this ending witnessed the first use of atomic bombs and heralded a period of deep suspicion and anxiety about nuclear war and mass destruction. The Cold War was a direct legacy of the Second World War. For the moment, though, the children of Skerton enjoyed the festivities.

ACKNOWLEDGEMENTS

The photographs in this book have come mainly from the collections of Lancaster City Museums. We are grateful both to donors of original photographs and to many others over the years who have allowed us to copy their photographs to add to our collections. We would also like to thank the following people and organisations for providing either help, information or permission to use their pictures:

R.W. Atkinson, Barry Axon, Duncan Blair, Myra Johnson, the *Lancaster Guardian*, Lancaster Reference Library, Morecambe Reference Library, Ken Nuttall, Ivor Parkinson, Robert and Rose Parkinson, John Pryce, John and Doreen Read, Ann Riley, the Speight family, *The Visitor* newspaper, Morecambe, Michael Walker and Hazel Wigginton.

The authors also wish to thank the staff of Lancaster City Museums for their assistance in producing this book.

BRITAIN IN OLD PHOTOGRAPHS

Northamptonshire

Northampton Past & Present

Nottinghamshire

Arnold & Bestwood:
 A Second Selection
Kirkby in Ashfield:
 A Second Selection
Nottinghamshire at Work
Nottingham Past & Present

Oxfordshire

Around Abingdon
Around Didcot
Around Henley-on-Thames
Around Wheatley
Around Witney
Around Woodstock
Banbury
Banbury Past & Present
Cowley & East Oxford Past
 & Present
Forgotten Thames
Garsington
Henley-on-Thames Past &
 Present
Literary Oxford
Oxford
Oxfordshire at Play
Oxfordshire at School
Wantage, Faringdon & The
 Vale Villages
Witney

Shropshire

Shropshire Railways
South Shropshire
Telford

Somerset

Chard & Ilminster

Staffordshire

Aldridge Revisited
Kinver & Enville: A Second
 Selection

Newcastle-under-Lyme Past
 & Present
Pattingham & Wombourne
Stafford
Stoke-on-Trent Past &
 Present

Suffolk

Bury St Edmunds
Lowestoft Past & Present
Southwold
Stowmarket
Suffolk Transport
Suffolk at Work: A Second
 Selection

Surrey

Cheam & Belmont
Esher
Richmond
Walton upon Thames &
 Weybridge

Sussex

Around East Grinstead
Around Heathfield:
 A Second Selection
Bishopstone & Seaford:
 A Second Selection
Eastbourne Past & Present
High Weald: A Second
 Selection
Horsham Past & Present
Lancing
Palace Pier, Brighton
RAF Tangmere
Rye & Winchelsea

Tyne & Wear

Whitley Bay

Warwickshire

Around Leamington Spa
Around Leamington Spa:
 A Second Selection
Around Bulkington
Bedworth Past & Present
Knowle & Dorridge

Nuneaton Past & Present
Rugby: A Second Selection
Warwickshire Railways

West Midlands

Bilston, Bradley &
 Ladymoor
Birmingham Transport
Black Country Pubs
Blackheath
Cradley Heath
Cradley Heath: A Second
 Selection
Darlaston, Moxley &
 Bentley
Great Bridge & District
Halesowen: A Second
 Selection
Ladywood
Ladywood Revisited
Lye & Wollescote
Lye & Wollescote: A Second
 Selection
Northfield Past & Present
Oldbury
Rowley
Sedgley: A Fourth Selection
Smethwick
Solihull
Stourbridge, Wollaston &
 Amblecote
Stourbridge, Wollaston &
 Amblecote: A Second
 Selection
Tipton: A Third Selection
Wednesbury
Wordsley

Wiltshire

Around Devizes
Around Highworth
Castle Combe to
 Malmesbury
Crewkerne & the Ham
 Stone Villages
Marlborough: A Second
 Selection
Salisbury: A Second
 Selection

Worcestershire

Worcester Past & Present

Yorkshire

Around Hoyland
Around Hoyland: A Second
 Selection
Doncaster
Huddersfield
Huddersfield: A Second
 Selection
Leeds in the News
Northallerton: A Second
 Selection
Pontefract
Sheffield
Shire Green, Wincobank &
 Ecclesfield
Wombwell & Darfield

Wales

Anglesey
Carmarthen & the Tywi
 Valley
Chepstow & The River
 Wye
Haverfordwest
Milford Haven
Upper Teifi
Welshpool

Scotland

Annandale
Around Lochaber
Clydesdale
Musselburgh
Perth
Selkirkshire
St Andrews

Ireland

Coleraine & the Causeway
 Coast

To order any of these titles please telephone our distributor,
Haynes Publishing, on 01963 442105
For a catalogue of these and our other titles please telephone
Joanne Govier at Sutton Publishing on 01453 732423